ABOUT FACE

·

ABOUT FACE

For: John + Audrey

[signature]

JOHN REEVES

Jan 23/14

TORONTO

Exile Editions

1990

This Edition is published by Exile Editions Ltd.,
69 Sullivan Street, Toronto, Ontario, Canada
M5T 1C2

Sales distribution
General Publishing Co. Ltd.
30 Lesmill Road, Don Mills, Ontario M3B 2T6

Designed by LOU LUCIANI
Typeset in STEMPEL GARAMOND by CAPS & LOWER CASE
Printed in Canada by HERZIG SOMERVILLE LTD.

The publisher wishes to acknowledge the
Canada Council and the Ontario Arts Council
for financial assistance towards this publication

ISBN 1-55096-000-8

Special thanks to my assistant Brenda Crooke
for her great contribution in both the studio and the darkroom

CONTENTS

I have had great friends and this book is dedicated to them.

SYLVIA FRASER

Author, *Photographed 1989*

When I go back in dreams to my early childhood, I find myself in a twilight zone: the zone seems very real. Its geography stretches around the western end of Lake Ontario from Bronte to Stoney Creek. Hamilton is the zone's principal city. It's always November 1944, it's always grey, windy and cold. I hear the Lake's iron-grey waters endlessly raging against the shore, and I am afraid. The morose weather makes pleasant prospects sinister; cruelty can burgeon in what would appear to be benign circumstances. The lovely old Grade School with the tree-fringed yard becomes the venue for daily thrashings to which my peers subject me for speaking English that loving relatives proudly call precocious. My best friend's sister is always sick and no-one really knows why. For a couple of years I find in chronic illness a refuge from flying fists. My father and the men he knows win their livings working in Canada's Steeltown – the zones *raison d'être*. The men work in factories with names which clang and thunk in the ear like shunting boxcars: Steel Car, Stelco, Carr-Fastener, Canco, Otis and International Harvester. The zone creates two kinds of people: those it needs to perpetuate the vitality of its mills and factories; and rarely, though implacably, those exotic anomalies – dreamers whom fists and fear have rendered into compulsive sojourners in worlds of their own invention.

I didn't know it at the time, but as a child, Sylvia Fraser shared my twilight zone and she is one of its exotic anomalies. The zone's perpetual November dark permeates her work. Pandora, the protagonist of her first novel, is Fraser's twilight zone persona. Pandora is a child and she lives in "Milltown." After a terrifying sexual assault by the friendly breadman, "Pandora is afraid, but she cannot name her fear. Pandora is ashamed, but she cannot name her shame. Fear and shame gorge like buzzards on her burden of guilty knowledge leaving only a few twisted bones." It was inevitable that Sylvia Fraser would become a dramatically beautiful woman – she is the pale delicate orchid that grew and thrived, rooted improbably in the cracked macadam of the "Trucks Only" route to a slag heap.

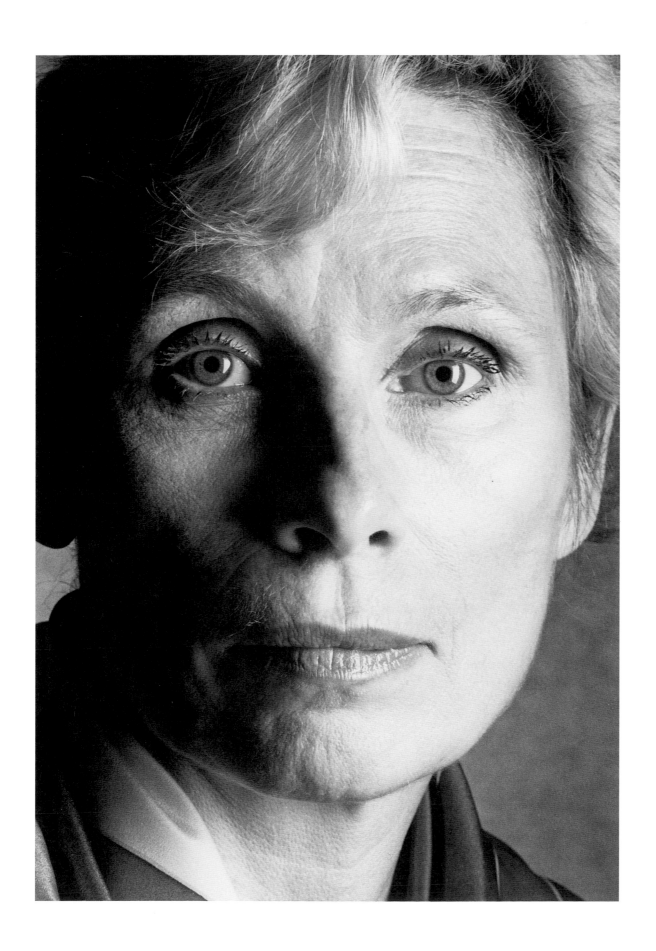

MICHAEL HOOD

Librarian, *Photographed 1990*

Our families were good friends. They lived a mile apart on the Lakeshore Highway, about 15 miles east of Hamilton between Burlington and Bronte. Mike was two years ahead of me at the same rough grade school. In the Forties, grade schoolers could fail academically. If you didn't get it right the first time, you repeated a year until you did. Strathcona School's student body featured a lot of big, tough, over-age, frustrated, angry kids. To be honest, a lot of them were immigrants who were having trouble learning English. They hated me and I got thumped around a lot. But for Mike Hood, I'd have been thumped around a whole lot more. Hood was aggressive and smart. He led a gang that could pull down pretty well anyone who bothered them. When they weren't totally engaged in the battles that passed for recess and noon hour, Hood and Co. would kindly run off my tormentors.

Years passed, the Hoods went to Hamilton, the Reeves went farming. I ended up going to Burlington High School. I was a lousy student. I was deemed weird by my peers. I couldn't dance, I couldn't get a date, and needless to say, I never "got laid."

Hood went to Westdale Tech and studied art. He was a gifted student. He was deemed just swell by his peers, especially the females. He could dance. He got dates, etc., etc. Hood spent spare periods and noon hours downing draft beers across the street from school, at Paddy Green's Hotel.

Eventually, I got weird enough to rate weekly encounters with a psychiatrist in Toronto. By this time, Hood was rooming in T.O. and attending a cram school to get some academic enrichment for his technical school matriculation. Hood and I started to hang out a bit. Hood was precocious and older. He sanctioned my interest in all sorts of things: art, architecture, film, and lots more. He introduced me to jazz, and along with that, the bars and night clubs where we went to hear jazz. He coached me in techniques for acting cool and looking old so I could drink under age. God, but I had natural talent. I still couldn't dance, get a date, or get laid, but I was a thing of beauty ensconsed on a bar stool at the Towne Tavern, grooving on Sonny Stitt, coolly ordering "another" from Shoesy the bartender. Hood's influence made it a lot quicker to go where I suppose I had to go in my life. I'm grateful.

We're still good friends. I spend a fair bit of time with Mike, his wife Ruth, and their daughter Susanna. These days, the friendship doesn't deal so much in mentoring as in mutal mid-life support. Ah, well …

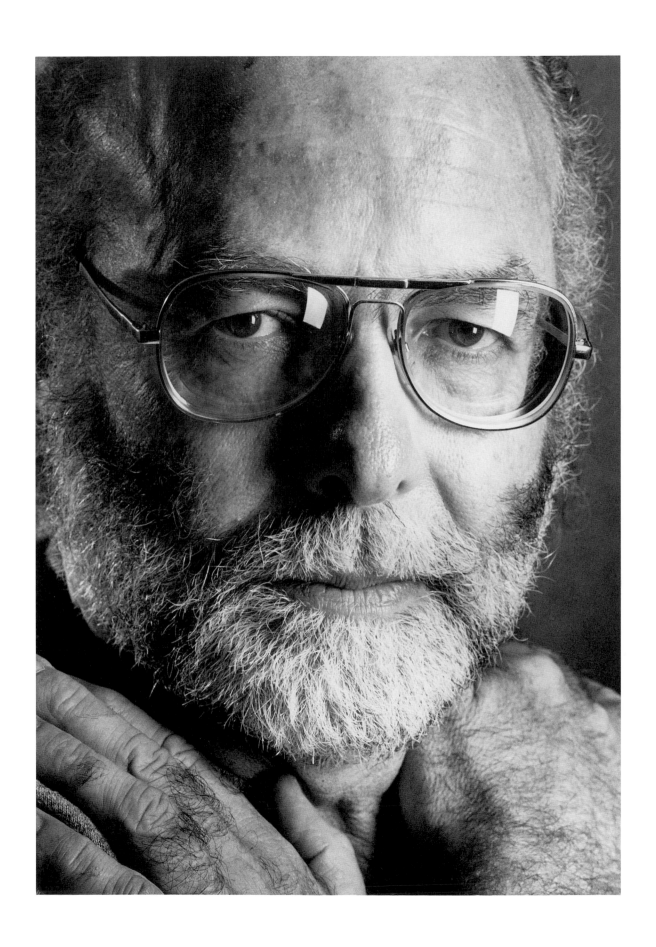

MARY GRANNAN

Author, *Photographed 1962*

Back in the days before Bill c58, the bill that exterminated Canadian editions of American magazines, *Time* was a lively market for parvenus photographers. *Time* served as a photographic bull-pen where you could warm up for the bigger and more numerous pages of magazines such as *Maclean's* or the now defunct *Star Weekly*.

This photo is the first of my literary portraits for *Time*. Mary Grannan had a considerable reputation during the 1940s and 1950s as the author of the Maggie Muggins children's books. Maggie's adventures were also the stuff of a long-running series of CBC-radio broadcasts for children. As a child, my mother approved of my listening to Maggie Muggins, her sunny innocent adventures with Mr. Magarity, the friendly gardener. Mom had not heard of Sylvia Fraser's friendly breadman. She did worry about rough tough radio yarns such as Hop Harrigan and The Green Hornet.

In 1962, the great New York photographer Irving Penn was shooting dramatically side-lit, tightly cropped faces. So was I.

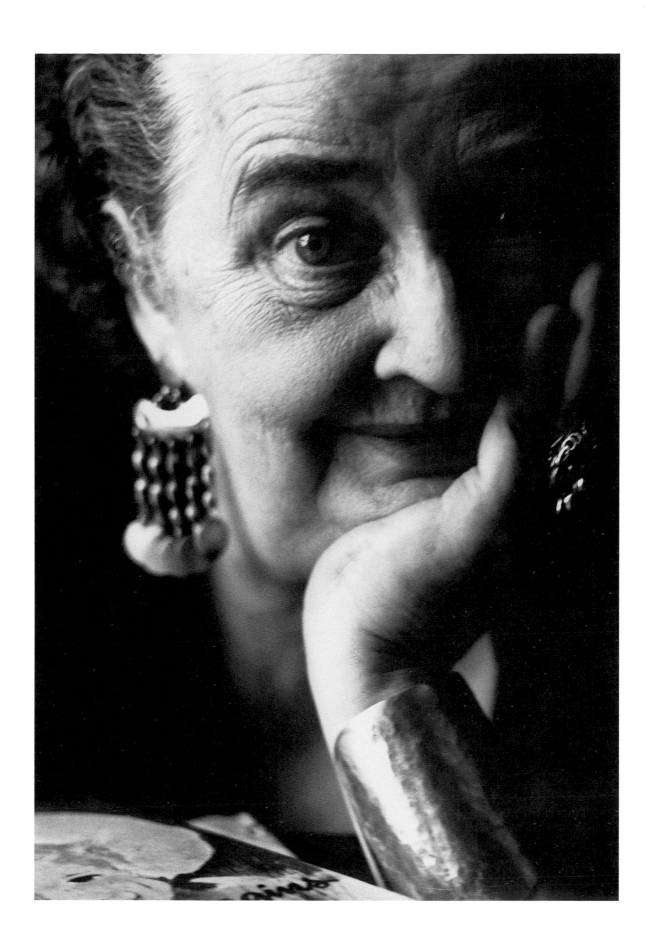

GENE LEES

Author, *Photographed 1988*

Some years ago, I worked in radio with a broadcaster named Charles Oberdorf. He was always quoting a u.s.-based Canadian-born writer named Gene Lees. Lees had been the editor of *Downbeat* and *High Fidelity*. He'd also been an essayist for *The New York Times, Saturday Review*, and a whole lot of other newspapers and periodicals. Since I'm a jazz lover, and since Lees' music journalism centered itself on jazz, Oberdorf was astonished that I'd never read the man he thought was one of the finest writers around. Gene still is one of the finest writers about music that there is. These days, he can be read in the pages of the monthly *Gene Lees Jazzletter*, which he publishes from his home in Ojai, California.

Once upon a time, Gene and I were both guests on a pilot production for a t.v. talk show that sought to present Peter Gzowski as a Canadian Dick Cavet (the cloning didn't take).

I discovered that Gene had been born in Hamilton. He was a brother twilight zoner. Gene's first job was working as the Burlington "stringer" for the *Hamilton Spectator*. It must have been 1948.

In those days, Burlington's waterfront featured a small harbor sheltered behind a cement sea wall. There was even a Burlington Yacht Club that numbered my father among its charter members. It was probably August and it must have been Saturday. Dad took me down to the harbor to swim. The Yacht Club fleet was coming and going, and suddenly a young man reached out to fend off a sailboat as it moved onto its mooring bow to the sea wall. The boat must have pitched, trapping the man's hand between it and the wall, her sharp prow cut his thumb clear off. The incident remained in my mind and for some reason I told the story to Gene. To my amazement, he had a vivid recall of the same occasion. He'd covered the "Yachtsman Looses Thumb" story for the *Spectator*. He must have been standing beside my Dad and me on the Burlington sea wall. It seemed strange to reminisce about the same bygone 1948 afternoon with a man I'd just met in 1970. We were sitting in the Fifth Avenue bar at Bloor and Yonge streets. We ordered a couple more large scotches, and then Gene told a part of the story I didn't know. The thumb could have been sewed back on but no one could find the damn thing.

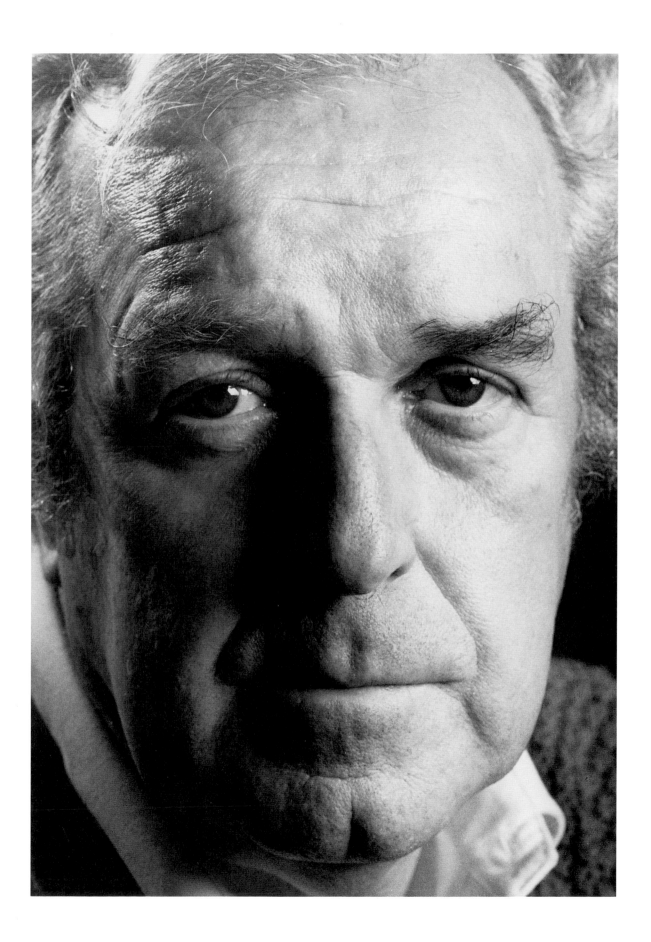

W.O. MITCHELL

Author, *Photographed 1981*

I think we evolve physically into a resemblance of people we admire. I should like to talk about my father and W.O. Mitchell. W.J. Reeves grew up in England and in 1925, the year he turned 23, he ventured to Saskatchewan, where he threshed for a season around Pathlow, homesteaded at Lac Vert, laid track to the Pas, and swamped logs near Melfort. Then, he moved to British Columbia where he revealed sublime talents as a vacuum cleaner salesman.

Dad admired W.O. Mitchell. He liked the way Mitchell wrote about the Saskatchewan countryside and its people. The Reeves are CBC aficionados, and when I was young, Jake and the Kid was approved Sunday listening. W.J. Reeves was the spitting image of W.O. Mitchell, at least from the bridge of his nose to the crest of his adam's apple. It's amazing! A generation after my father, I have different heroes. I bear an astonishing resemblance to Mordecai Richler, particularly if you stand a little behind me at the right angle.

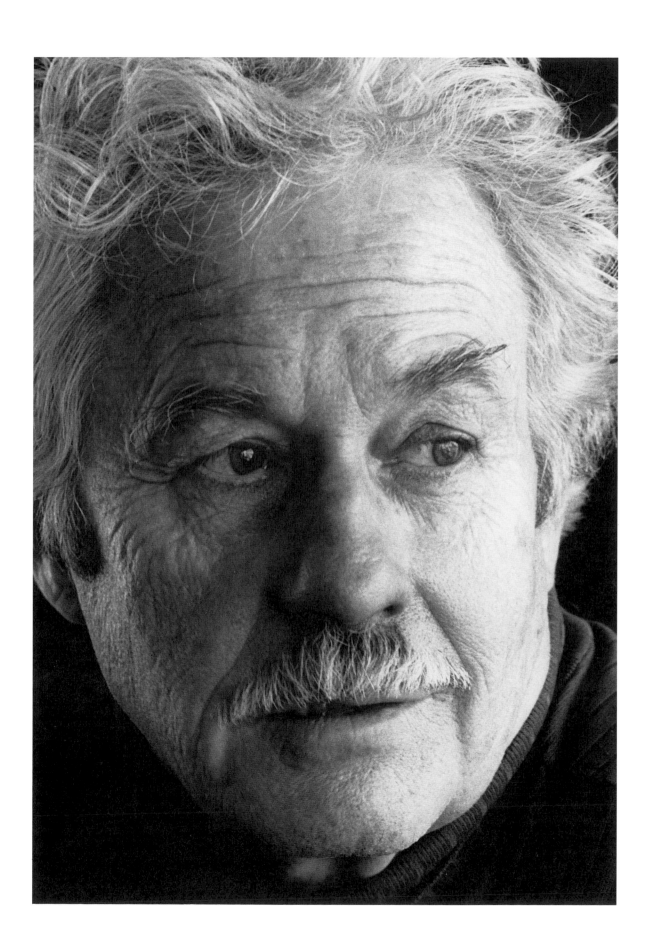

MORDECAI RICHLER

Author, *Photographed 1983*

"It's nice to see you again Mr. Richler," the young, recently appointed, reception clerk at the Ritz Carlton Hotel said. "That's not Mr. Richler, that's Mr. Reeves," said a bellman who's been *schlepping* my gear in Montréal since 1966.

So there you have it: the Richler/Reeves resemblance. Consider the unruly hank of hang-down forelock, the soaring widow's peak, the indescribable though distinctive chin.

Viewed from the rear and a little to the left, the similarity is more startling. I once found myself sitting behind Mr. Richler in the Ritz Carlton's Maritime Bar when – for a brief disconcerting moment – I thought I was being invited to check my own "back and sides" in the McLuhanesque rear-viewing mirrors of a grand barbershop.

Richler and Reeves are known to be verbal, extroverted men, yet our photo-session was an almost silent encounter. Since we tend to evolve physically into a resemblance of the people we admire, I would like to think Mr. Richler was touched by the knowledge that our strong facial semblance reflects the affection and admiration I have developed for his written work and public personna.

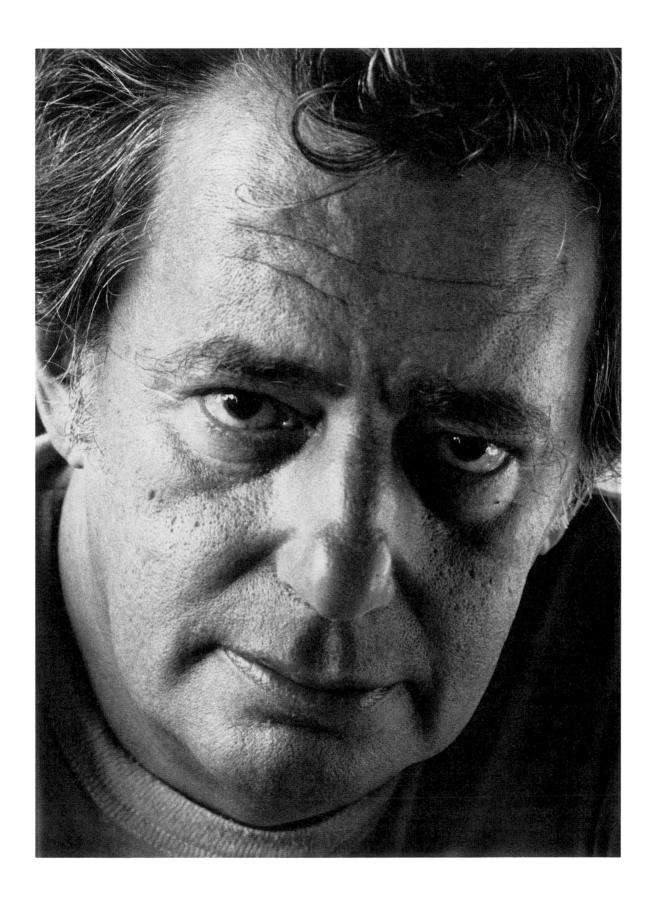

CECILIA JOWETT

Author, *Photographed 1965*

People are seldom at ease with their own portrait. The physical image you create rarely conforms to the mental image they have of themselves. There are, however, exceptions to this rule, and Cecilia Jowett was one. Jowett spent the greater part of her life working as a country nurse, first in a pioneer community near Cochrane, and then in Longford Mills, a village nine miles north of Orillia, on Lake Couchiching. While living and working in the Orillia area she got to know Stephen Leacock, who encouraged her to write about herself.

Jowett's autobiography, No Thought for Tomorrow, was published by Ryerson Press in 1954. Miss Jowett was an old family friend, and when she learned that I had become a photographer, she asked me to produce a portrait of her, which I did in March, 1965. Her poignant response to the pictures I shipped to Longford Mills was unexpected and touching. I quote her letter in part: "The photographs came safely and I do thank you, for the honor you have shown me in granting my wish that they are yours, your work, and mean much more to me therefore. One pose, quite unconsciously on my part, is like "Whistler's Mother," so nothing is really new under the sun.

"The strain and stress of the past years shows clearly in my face ('faces') and they are truly real and characteristic. The large photographs I will hang at some distance, to get the best effect and ask myself often, 'See what life has done to the pretty girl in the locket, at 16 years of age'The lack of money for good skin cream over the past 35 years didn't help the wrinkles; but then, again, it is myself as I am today and neither Heaven nor – – – – can alter it."

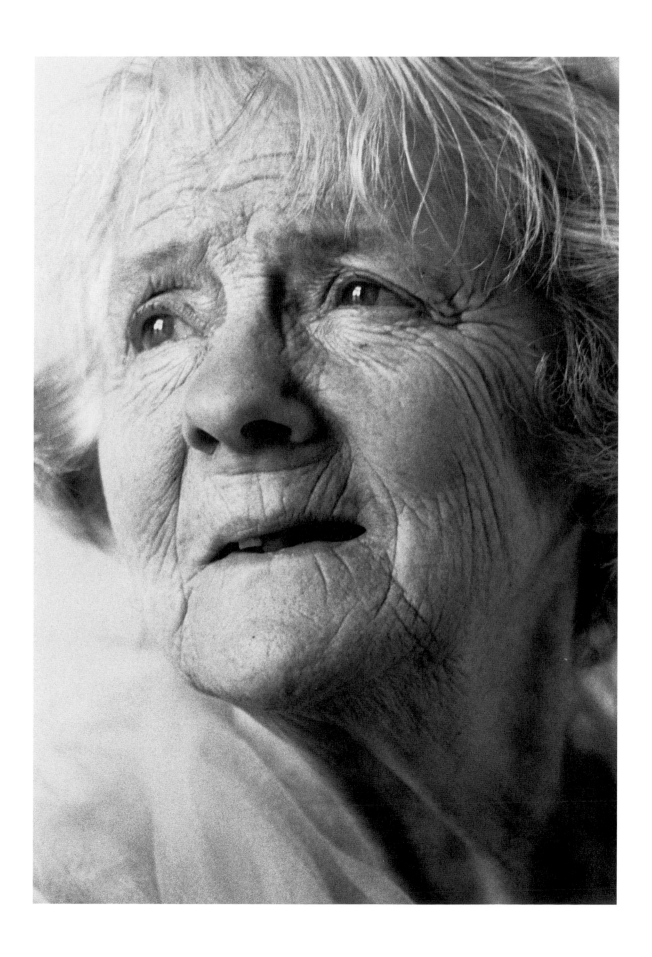

DEBBIE GIBSON

Publisher, *Photographed 1989*

Over the years, I've learned that being an only child allows you the privilege of selecting your own siblings, rather than having them thrust upon you.

Apart from passionate attachments, I seem to have a capacity for female pals. If the female pal is a whole lot younger, I tend to think of her as a sort of niece. If she is just somewhat younger, I think of her as a sort of sister.

Debbie Gibson is an exuberant, much-adored younger sister. Her father is a longtime friend and that's how I met Debbie in 1972, just after she graduated from Queen's University. At twenty-three, she was beautiful, brilliant and funny. We became pals and I'm sure glad we did. Exuberant young sisters respect your ideas and achievements. They persuade you that you're not all bad. They advertise your talents and shepherd you through emotional bad patches. Everyone needs a splendid self-selected sister.

Debbie went into the publishing business. She was such an awesome space salesman that she was made publisher of *Toronto Life Fashion* the year she turned thirty; the first female to publisher of a major Canadian retail periodical. You think her dad and I were pleased. Damn right.

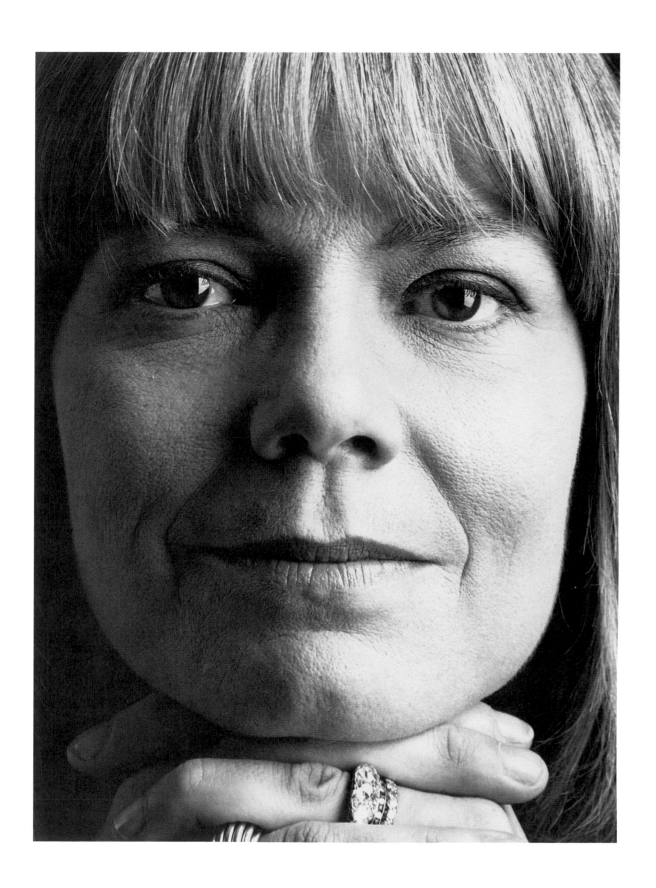

ROBERTSON DAVIES

Author, *Photographed 1978*

Like its neighbor the United States, Canada has a South – even a Deep South. Both regions lie in Ontario. South means anywhere south-west of Ottawa: Deep South means south-west of Brantford. One could think of Chatham and Saint Thomas as our Charleston and Savannah. Our Deep South was settled sooner and more intensely than most other regions in the country, and early on it became affluent and cultured. It is the cradle land of many of our greatest intellects; John Kenneth Galbraith was raised near Dutton, and Robertson Davies was born in Thamesville. In his Deptford books – Fifth Business, The Manticore, and World of Wonders – Davies is our kind of "good ole Southern boy," travelling by trilogy to the darker corners of our Southern soul and psyche, revealing a distinct decadence and charm, feeling the energy of our South's drive for achievement and power. Among other things, Davies' books trade in what might be called a Jungian sensibility; magic and dreams, the inexplicable. He is the Great Conjurer, and I thought he should look the part.

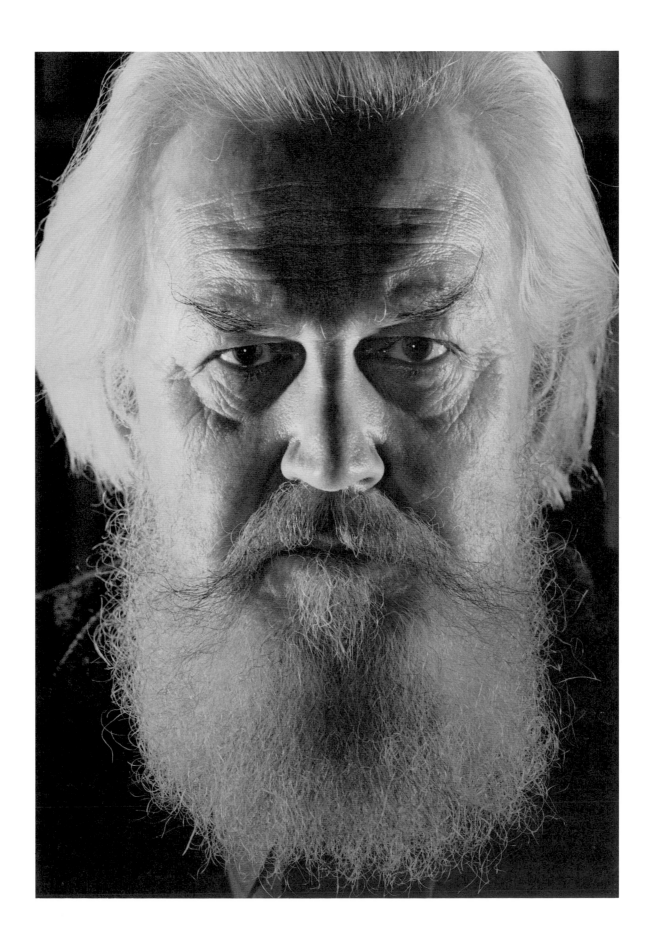

JAMES HILL

Illustrator, *Photographed 1990*

Jimmy Hill is another anomalous Hamiltonian, a steel town dreamer. Born 60 years ago, the son of a master plasterer, Jimmy grew up longing to know the grander world which first appeared to him in the magazine and book illustrations of Maxfield Parrish, N.C. Wyeth and Arthur William Brown. Jimmy loved to draw and he was fascinated by the near past of America. The period from 1880 to 1930. He spent hours in his parents' basement listening to his father's treasure trove of Scott Joplin 78's. And more hours in the tintype brown ambiance of family photo albums and scrapbooks. In time, he found literary figures who fed his intrigues, the gracefully elegant "grotesques" who haunted the works of Sherwood Anderson, then there were Scott Fitzgerald's "golden ones," and the legendary New Yorkers of Lucius Beebe's journalism. Hill came to dominate the Canadian illustration scene. In New York City, he became a major presence in *Family Circle, Good Housekeeping, Redbook, Ladies Home Journal, McCalls, Playboy* and *Look*.

Notoriety and honors came his way. Women he was never to meet wrote him passionate fan letters. He won countless Art Director's Awards, and the New York Society of Illustrators twice presented him with gold medals. Finally, in the summer of 1966, the year that his hero Maxfield Parrish died, the élite Society of American Artists named him Artist of the Year, an honor hitherto conferred only on Norman Rockwell and James Spanfeller. He should have earned a six figure income and a mansion in Connecticut, but his shining hour came just as the Golden Age of magazines was ending. The vehicles for his work grew physically and fiscally smaller. All this, coupled with the death of his New York business agent, left him with few markets for his work. Though there are occasional demands for his illustrations, tax troubles, divorce and diminished income, have dogged him through the years since 1966.

Finally, frustration and no little despair drove Hill to create his greatest work of Art – his present self. Recalling the tinkling elegance of Joplin's piano, the timeless serene world he had found in photo albums, the social graces enshrined in Fitzgerald's golden people and Beebe's mythic kings of the avenue, he rendered himself an embodiment of the ideals they conveyed. He became, not a man who might have existed in 1910, but a man inspired by the ideals rather than the facts of a period he never saw; he became a synthesis of those ideals.

Sometimes late at night, mellow with malt whiskey in the quiet of his tiny home, Jimmy goes in dreams to dinner at Delmonico's, followed by a revel with wonderfully witty friends admidst Parrish's glorious murals in the St. Regis bar. Then, of course, there is a buggy ride home up Fifth Avenue with a dear companion, to the discreet comforts of a suite at the Stanhope. There never, ever really was a gentleman like Jimmy Hill.

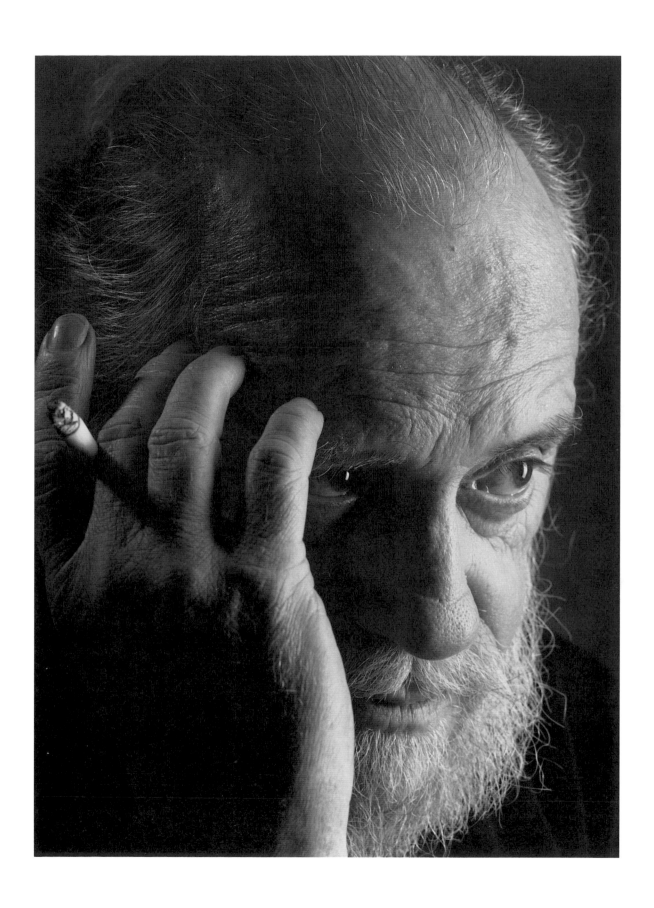

THEO DIMSON

Graphic Designer, *Photographed 1990*

The graphic designers Allan Fleming, Theo Dimson and Arnaud Maggs, the illustrator James Hill, and the photographer Paul Rockett, are the five people who manouevered the printed environment from what it looked like in the Thirties and Forties toward what it became in the post-war era. Their influence is still evident. They laid hands on the taste of their times and they changed it.

If you haven't seen Theo Dimson's designs, you've been living in Botswana: his packaging, his fanciful fashion advertising, his countless stylish posters for almost every cultural organization around, and on and on.

It's fascinating to see how the designing minds can render themselves into embodiments of the people, places, and times that attract them.

Jimmy Hill became the urbane 1920's New Yorker who never really existed. Theo Dimson reaches both farther afield and further back in time. His style is 19th century French. In summer, he is white and pastel topped off with a stylish straw hat. He blends in nicely at one of the casually elegant champagne soaked revels depicted by Renoir and Manet. Winter is another matter. Then, he's all dramatic dark top coats, drooping black Borsellino hats, and splendid, very tailored three-piece suits. He is an emphatic dark shape, a poster-ready graphic. The winter Dimson is an image from Toulouse Lautrec, M. Aristide Bruant making his entry into the Moulin Rouge.

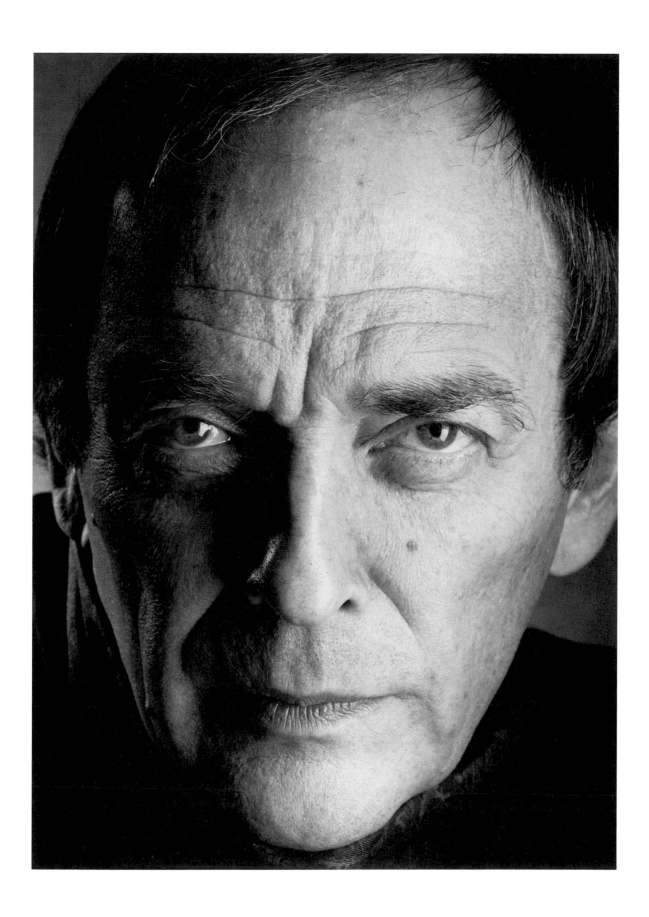

ALLAN FLEMING

Graphic Designer, *Photographed 1974*

Allan Fleming was the most influential Canadian applied artist of his time. He had a tragically short career. Fleming worked as a graphic design consultant, an advertising agency art director, and finally a book designer. In 1960, he designed the Canadian National Railways corporate marque. He designed a lot of things but his C.N. is the best corporate marque ever designed by anyone anywhere. It's a single simple line that evokes a gigantic enterprise's complex functions. To this day you can see a Fleming design exhibit by simply heading down to the tracks and looking for a string of boxcars.

Fleming's consulting work was done out of the design department that he headed at Cooper & Beatty, Toronto's pre-eminent typesetting house. After Cooper & Beatty, Fleming spent two unhappy years as art director at *Maclean's*. Maclean Hunter has never been a happy roost for art directors. and they have moved an awesome array of design talent in and out over the years. So, 1962 found Fleming looking for something else to do. He met George Elliot.

Elliot was the number one guru of everything at Maclaren's, the number one advertising agency at the time. Elliot persuaded Fleming to leave *Maclean's*. Fleming's phenomenal facility for conceiving visual metaphors for verbal ad concepts and his further ability to articulate his reasoning – here is the problem, here is what I've done about it – quickly moved him up through Maclaren's, from group art director to vice president and creative director.

It was probably late in 1965, when Lorraine Monk, then head of the National Film Board's Still Photo division, invited Fleming to design Canada: A Year of the Land. The book became a classic. It is impeccably fine. After designing a major book, he didn't want to do a whole lot else. He left Maclaren's to head up the design department at the University of Toronto Press. He became obsessed with the intellectual and aesthetic problems unique to books. His department started scooping awards worldwide. When Allan Fleming died in December 1977, aged 48, Canadian books lost their greatest architect.

There was more to Fleming than a rare personal talent for design. The man had a huge need to teach, to spread the word. A list of protégés reads like a designers who's who; Neil Shakerey, Jim Donoahue, Ken Rodmell and a very long list of others. Fleming not only influenced graphic designers as a mentor, employer or friend. He affected large numbers of people working in related disciplines: illustrators, all sorts of authors, myriads of graphic arts craftsmen, cartoonists, cartographers and photographers. He even supervised the design of *Exile*, the literary quarterly that became the seed-kernel to Exile Editions.

Allan Fleming was my first client. His interest in my career continued to his death. The crowning achievement in my first decade in business involved collaborating with Fleming, the photo-engraver Ernest Herzig, and Dorothy Cameron (as writer) in producing a book presenting the work of the sculptor John Fillion. Thanks to Fleming's ingenious design and Herzig's superb printing, the book won all sorts of awards for design and production, including acceptance in the 1968 American Institute of Graphic Arts Book Show, the Academy Awards for visual books. The late Sixties was a low point in my career. The successful collaboration with Fleming was badly needed dazzle on an otherwise dark rainy day.

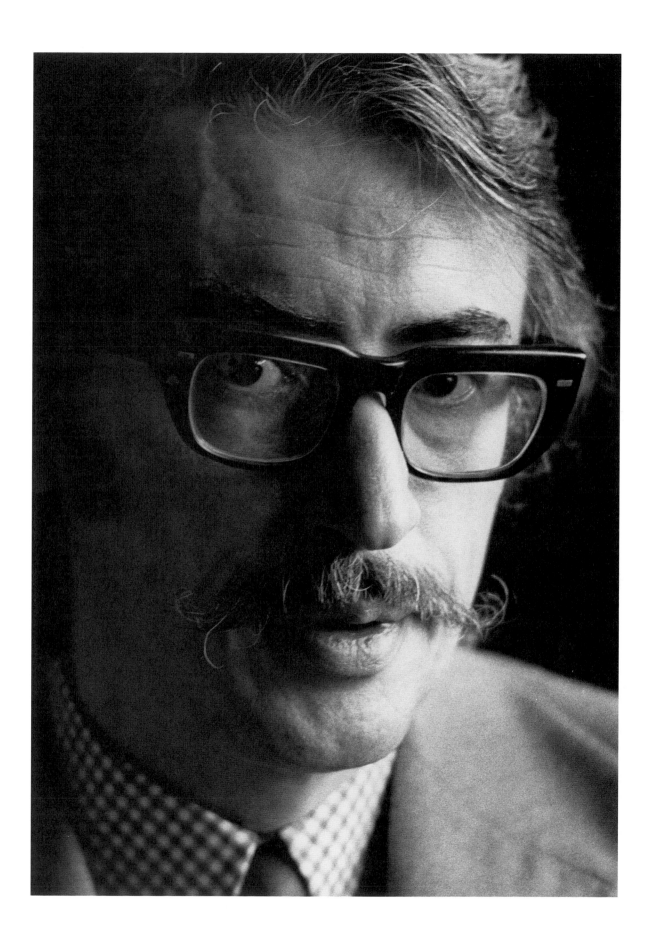

GEORGE ELLIOT

Author, *Photographed 1989*

There was life, not to mention survival, before Atwood. *Time*'s Toronto bureau chief, Serell Hillman, was of a very literary bent and he loved to write stories about authors. I remember Serell describing George Elliot's new (in 1962) book, *The Kissing Man*, as a masterpiece, a milestone in contemporary letters. Serrell was right.

George Elliot was vice-president of Maclaren Advertising when Allan Fleming introduced us. I did a lot of work for George after that. He sent me to the Arctic, I photographed Pierre Trudeau. He was eccentric, brilliant and mysterious. I could never figure out what sort of vice president George was. His goings-on fitted none of the basic agency job descriptions. He walked around with his hands in his pockets, somehow galvanizing everyone around into furious action on his behalf. I don't know how it was done. It had something to do with being evident but not tangible.

There are times when stories give clues to the nature of their teller. Evident but not tangible. When George wrote about the evident intangible protaganist in the *The Kissing Man*, he was writing about himself:

She had to turn around. She would never be able to tell why. She just had to. The kissing man was there close to her. All in his face was pity. He took her hand firmly in his two. He pressed her palm to his cheek.

"Oh God," he whispered, "why does it have to come to this?"

His voice trailed off. He dropped her hand.

Who lived once, and was a person to love, now is a wisp of loneliness. Why is it that order of living, loving and loneliness? Why do I see it wherever I go? I dream of taking you, Miss Corvill, and loving your body with my eyes, touching you, making you cry for shame until the shame is out of you, making you cry then for that, and giving it, giving it all. The way no man ever did. And it's the end. The end of loneliness that leaves you dust. Why do I see it wherever I go? Living, loving and loneliness.

He left the store.

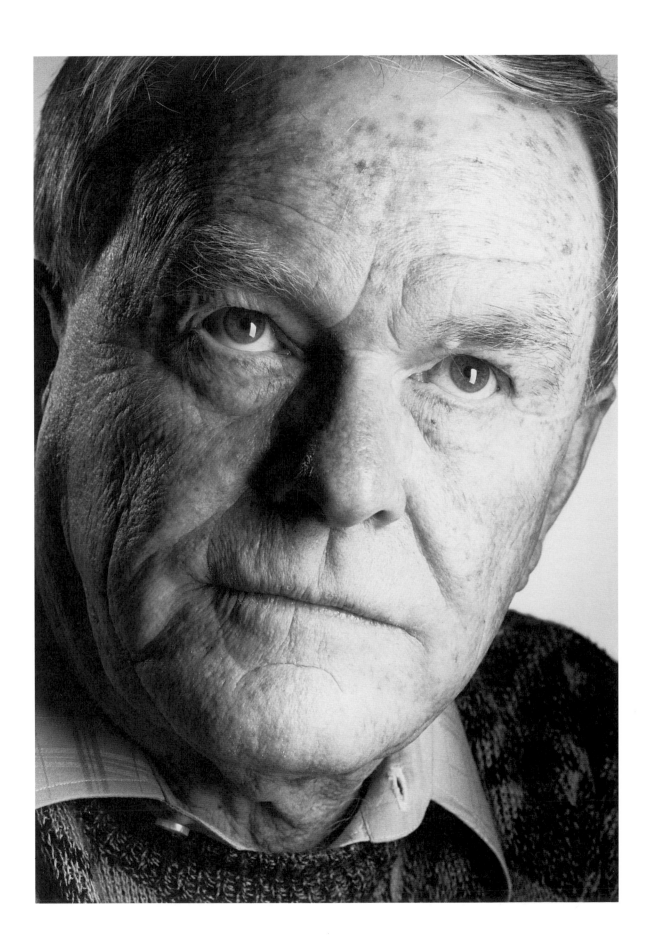

ARNAUD MAGGS

Photographer, *Photographed 1990*

In the Fifties, Arnaud Maggs was a very successful commercial artist. He wore impeccable Ivy League clothes: trim three-button jackets, button-down shirts, ties and pants with killer creases. He had a lovely blond wife and three kids. He lived in E.P. Taylor's idea of the Utopian post-war residential community, the Toronto suburb called Don Mills. Maggs' life was a perfect design.

In the late Sixties, he abandoned his important career as a graphic designer to become a photographer. Long before it was fashionable (its now unaffordable), he went to live in a wonderous pile of Victorian gingerbread located in the old inner city residential district known as Cabbagetown. He accumulated a huge collection of antique dolls. His marriage dissolved. The women in his life were pale exquisite flower people. They had reed-like bodies. They didn't talk much. Maggs grew a beard and wore caftans. His new life was a perfect design.

As the years wore on, Maggs' apparent lust for re-arranging himself persisted. There was a tonsured Arnaud who dressed in black and lived in a vast loft fitted out with a futon, an Advent hi-fi, a Hassleblad camera and a beautifully equipped darkroom that occupied a small corner of what was otherwise a vast empty daylit space ideal for practising Ti-chi. His loft life was a perfect design.

Maggs pursued photography with the same rigor he had brought to graphic (and life) design. There was a search for who he wanted to be photographically. He wasn't happy with his early forays into fashion and feature portrait photography for magazines. He took a photographic sabatical to draw the nude for a while, and by 1975 his draughtsmanly contemplations led him to start producing an enormous body of portraiture that continues to grow. Maggs' portrait attack involves his sitter turning on one spot through 360 degrees. The resulting 12-exposure sequence of negatives becomes the raw material from which he makes his finished work. His pieces trade on the camera's capacity to be an analytic recording tool that is able to render exquisite photographic detail. Also, they can be seen as very designed, very Maggsian op art works.

Calgary's Nickel Museum invited him to design and install a major exhibit of his work in 1984. Maggs produced the work and designed the space. It was wonderful to see someone get the opportunity to make his statement fully. Love it or hate it, the Nickel show was a seamless presentation of exactly what Maggs meant to say photographically, it was another perfect design.

MORLEY CALLAGHAN

Author, *Photographed 1989*

Over the years I had three photographic encounters with Morley Callaghan. This photo is the outcome of a very recent shoot at my studio in Toronto late in December '89. The first time I photographed Morley he was pictured with his two sons and his wife Loretto for *Toronto Life* in 1972. The second photo session with Morley happened six years later in the summer of '78.

George Elliot was working as director of communications at the Canadian Embassy in Washington and the Embassy's magazine needed a Callaghan portrait for its cover. During our '78 get-together, Morley reminisced about a 1943 photo-session with Yousuf Karsh. Karsh had never released any of his Callaghan portraits and Morley speculated that things just hadn't jelled with him and Karsh and the photos were all failures. The whole thing sounded a little odd to me. Mr. Karsh seldom if ever concedes to defeat in the face of a portrait problem and sure enough a few weeks after my visit chez Callaghan a new volume of collected portraits – Karsh Canadians – hit the street with an imposing moody Morley portrait all over page forty.

I've always figured Mr. Karsh as a very waste-not-want-not sort of a guy. That pic was going to surface sooner or later. Around the same time that Karsh took that photograph, a young man from Hamilton shyly tapped on Morley's door at 123 Walmer Road in Toronto and said, "I love your stories, can I talk to you?" Morley talked and Gene Lees listened. The legendary Callaghan eloquence was more than sufficient to keep Gene steadfast in his ambition to be a writer. Morley always loved talented young writers and he never doubted that Lees could deliver.

MICHAEL MAGEE

Actor, *Photographed 1990*

Even a fairly brief exposure to Michael Magee's life and thought is enough to evoke the sense of a very refined mechanism under great stress. A high performance fuel-injected engine operating at peak revs with its cylinder heads glowing in the dark.

Magee the actor created a comic persona, a Beamsville, Ontario farmer named Fred C. Dobbs, to function as a conduit for his rage to react to the times not unfolding as they should. Fred was launched in 1968, doing on-air talks (by pay phone from the general store) with CBC radio's morning man of the moment, Bruno Gerussi. Fred was hell on wheels. He belabored walking, talking bags of excreta wherever he found them, which frequently meant Parliament Hill and Queen's Park. Dobb's satire was savage and very funny.

At about the same time, another actor created another farmer persona who made his way onto the airwaves. Charlie Farquharson is a farmer from Parry Sound who appears to be the victim of a degenerative brain disease whose symptoms are an inability to communicate due to a devolution of his verbal communication into an aimless glossolalia of punning word play. As yet, there is no treatment for Farquharson's Syndrome.

At this point I have to speculate on the on-going success of Farquharson's syndrome as Canadian entertainment. Fred C. Dobbs' gonzo satire has gradually faded out of earshot while Yore Purry Sewn Punster has burgeoned into a (100's of radio and television appearances as well as seven books) major multi-media event.

To be fair, let's sample Fred's and Charlie's prose. First Fred from his second of two books, *The Platinum Age of B.S.*, and the chapter entitled *Droppings From a Trojan Horse.* He is annoyed by intrusive T.V. commercials:

> *... we're talking about some mythical broadcaster televising a horse race now ... and, Jesus, they cut away to some halfwit lifting his beer on his deck in Northern Ontario while a bunch of pot-bellied arses show up in a canoe and some women with white-on-white teeth drop in by balloon. And geez, some of them women look they seen more ceilings than Michaelangelo.*

Now here's Charlie, from his seventh of seven books, *Cum Buy the Farm*, and the chapter entitled, *Up to Yer Arts in Culcher*:

> *Valeda sez all that ain't culcher, jist recremational fun. Her idee of reel culcher is lissenin to sumthin like Lone Grin. I tole her I bin lissenin to him ever sints he dun the noos durin the war makin Canda Carry On with the Voice of Gloom, till he cross-over to the Straits and becum father of ther cuntry on the Poundaroaster Ranch, and end up sellin dogfud, witch maid me stay away frum them Poundaroaster Restrunts.*

Do you think the people 'round Parry Sound bust a gut laughing at this stuff?

Charlie Farquharson is the creation of an actor named Done Old Hair On. This man Hair On must be a bright guy, because he understands that in Canada punning glossolalia flies while satire born of a rare moral outrage dies. But God damn it, his cylinder heads don't glow in the dark.

GEORGE CUTHBERTSON

Yacht Designer, *Photographed 1990*

There are rare moments in life when intentions and actions collide with opportunity. A man is suddenly able to make a perfect gesture, to create a masterpiece. George Cuthbertson's moment came on a November night in 1965, between the second and third periods of a hockey game at Maple Leaf Gardens. His friend and sometime client, the yachtsman Perry Connolly, challenged George to create "the meanest hungriest forty-footer afloat." The boat came to be called Red Jacket and her design embodied everything George knew about sail boats. Red Jacket was the first yacht hull to save weight by using a Balsa wood core sandwiched between inner and outer fibreglass skins. She was extra light fore and aft to reduce pitching, enabling her to make better way in choppy water. A fin keel that joined her hull at a crisply defined near-right angle – rather than the more typical gently swelling keel hull interface – enhanced speed by greatly reducing drag. Red Jacket had a tall sailplan that made her very fast in "light" air. The fine tuning of her aqua and aerodynamics were such that she was equally efficient sailing up wind or down.

Red Jacket was an astonishing boat. She soon became a legend. In her first season, she won eleven of thirteen races, including the Freeman Cup, the Lake Ontario International, and the Prince of Wales Cup. An exuberant Perry Connolly was ready to set off in hot pursuit of greater glories.

Connolly took his new boat south in 1967 to Florida and competition on the Southern Ocean Racing Circuit. The s.o.r.c. represented the very big time for international yachtsmen. The annual five-race series was a nautical Grand Prix. Red Jacket was a small dark horse entry from a country that had never been a presence on the circuit. Her debut was stunning; three firsts, one second and a flukey twenty-third, for a second place standing – not just in her own class (based on size), but overall against a 95 boat entry.

The following year Connolly took Red Jacket back to s.o.r.c. This time there was no flukey twenty-third placing. Red Jacket cleaned up: first in class and first overall. To grasp the degree and scale of this achievement, imagine a Canadian designed and built racing car with a Canadian driver humiliating Porsche and Ferrari at Le Mans. Victory vindicated Red Jacket's design innovations. She was one of the best racing yachts in the world. Her owner, the urbane sportive Perry Connolly, added greatly to an already considerable reputation as a brilliant racing sailor. She did one other thing, she made George Cuthbertson very famous.

Red Jacket is a marine masterpiece, the logical nomination for the first modern Canadian racing yacht to be acquired by a National museum.

NORTHROP FRYE

Scholar, *Photographed 1978*

Northrop Frye writes books that explain writing. He tells other writers what they write about. Frye is courteous and shy, a Castiglione in the bush garden. Courtesy is hard to photograph, so there is a lot of shyness in the photo. I'd like to think that there is also a frisson of the flinty toughness that made a lot of Frye's post-graduate students nervous if not downright wary.

I wasn't sure how shy flintiness was going to play with Nicholas Steed, editor of the now long defunct *Quest*. However, Judith Finlayson's text for the *Quest* story made much of Dr. Frye's shyness and Steed ran my picture next to a heading that read: "The Fearful Shyness of Northrop Frye" – and a subheading said, "The Most Formidable Mind in Canada: The Man Behind the Mask."

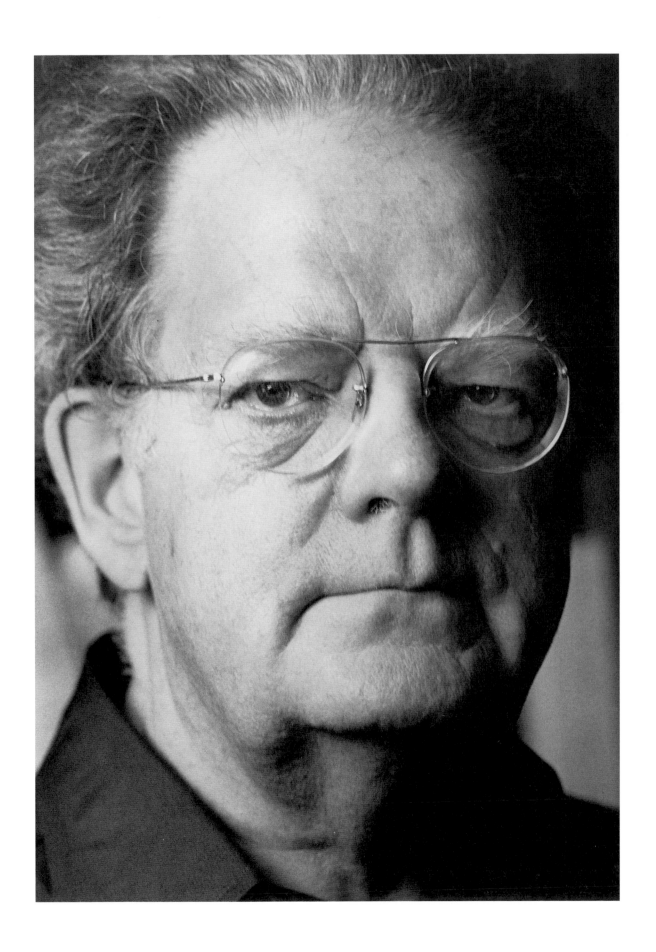

NORMAN LEVINE

Author, *Photographed 1982*

The short story writer Norman Levine is a verbally and visually literate man. As you can see, he sometimes likes to draw in the air with smoke. Art and artists fascinate him. The painter Francis Bacon is one of his best friends. These are two very different men. Bacon is the creator of some of the most violent imagery in contemporary art. Levine, in contrast, is the author of gently modulated fiction. They share an interest in photography, but Bacon is fascinated by photographs that reveal the human form subjected to physical stress – the prize fighter's face grossly distorted by the impact of an adversary's fist. Levine talked to me about the way photos freeze a moment permanently, and the poignancy of looking at a picture that preserves someone in youth, vitality, and vigor – someone we know to be long dead.

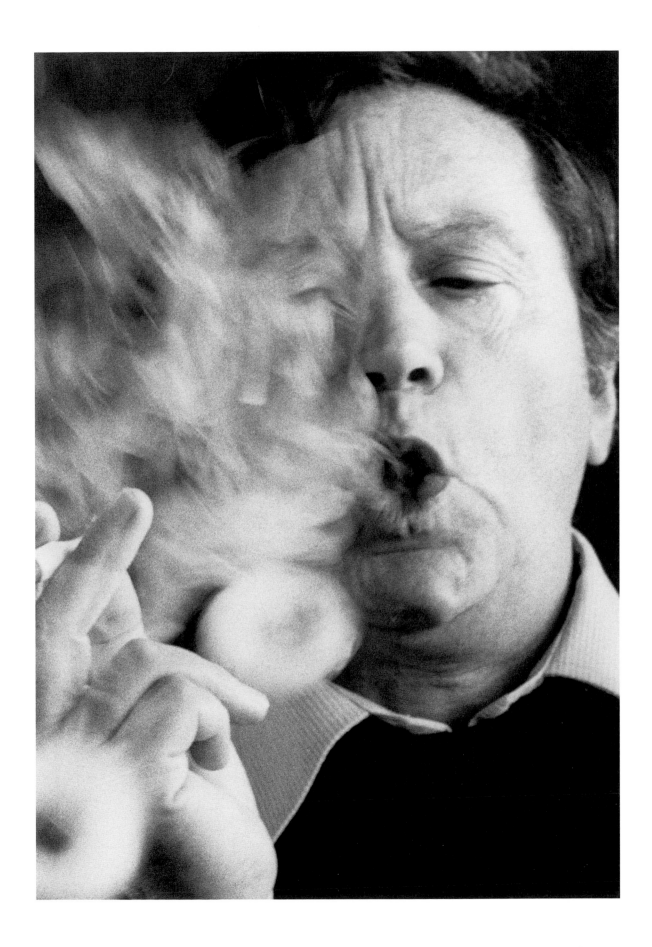

ROBERT MARKLE

Artist, *Photographed 1984*

"Hey man are you a fag?" In 1957, anyone who spoke well was suspected of homosexual tendencies, and for better or worse, I have always known how to speak well.

Robert Markle and I were standing among an archipelago of beer cases strewn along the hallway of a seedy roach-ridden walkup on John Street near Queen that served as housing for some students attending the Ontario College of Art. It was Saturday night. It was party time, and I was a first year art student looking for the *vie boheme*. Markle and I were shit-faced and I don't remember my response to his more than a bit rude question. I do know that when I was young I was heavily into liberal tolerance, human compassion and non-violence (I like to think I still am), so my answer must have been carefully considered and perhaps imbued with gentle rebuking humor. Of course, I may simply have said "fuck off" in a very gently balanced way. At any rate, we became and remained friends for the next 33 years, up until Bob's death in a truck–tractor accident, July 1990. There were a lot of ways in which we weren't much alike, but maybe growing up in and around Hamilton had something to do with our amicability. What can two steel town dreamer jazz buff wackos do except be friendly.

We did share a fascination with strip joints and strippers.

Markle found his strippers in Buffalo, which in the Fifties was still a seductive hunk of neon night-street America, just down the road from Hamilton. Markle saw his strippers as towering, gloriously lascivious heroic female icons.

I found my strippers in Montréal, where I had gone to art school for a year in 1956. I saw my strippers as vulnerable human beings who were as worthy of God's love as say, Vesper Noble, the Anglican Minister's daughter who was the object of one of my first utterly unrequited loves.

Strippers became a lifelong leitmotif for Markle's prolific output of exuberant, sensual drawings and paintings. Strippers have never been a big part of my photographic career, although I continued to visit strip joints for a fair number of years – with my liberal God-loves-them-tolerance somehow twangled neatly round my tumid lechery. By then, I was sure that Vesper had released me to lust.

I have always admired Markle's art and I own two of his earliest stripper drawings, but there was another side to Bob. His love of and talent for good conversation. Markle read books. He read real books. Great fiction. He was brilliantly articulate about a wildly eclectic range of interests, and he was capable of enchanting wit as well as scalpel sharp critical insights.

The sudden death of a contemporary has extra jolt to it. By age 52, I know that everyone dies and I also know that as a photographer my job is to mumify moments in the lives of my subjects. The vital photographed moment lives on forever. The person that moment belongs to ages and dies. All the Inuit artitsts I photographed in 1968 are dead. Marshall McLuhan is dead, so is Gabrielle Roy, and so are a lot of other people. For all my morbid mid-life insights, I'm not yet comfortable mumifying moments in the lives of people my own age.

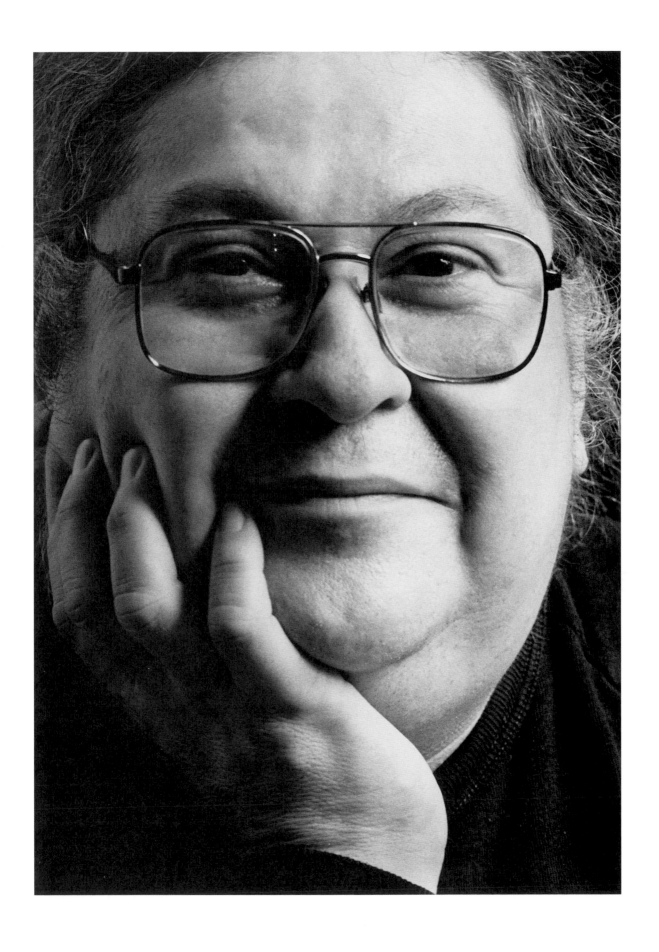

MAX MACINTYRE

Banker, *Photographed 1989*

I could never lay claim to knowing what bankers think about. But I may have an inkling into what one banker thinks about.

As a child, Max MacIntyre dreamed of becoming a banking star with an intensity that his peers reserved for hockey. He tried studying engineering, but that went nowhere. He dropped out of University to become an errand boy at the Bank of Commerce's main Toronto branch. After that, he worked his way up, a very long way up. Max is a senior vice president of the Canadian Imperial Bank of Commerce.

For Max, banking isn't really a job. It is a calling, like the priesthood. As he contemplates the judicious management of money, the management of offshore wholseale operations, the management of national and corporate financing, it's clear that he sees all this as an activity to be informed by complex moral and philosophical considerations. The judicious assignment of credit worthiness to a nation requires careful analysis of how that nation is behaving in the world, its short and long term prospects. He's a practical visionary. Lebanon, for example, is a tragic mess in 1990 but how do we see her in 2040. Max worries about how the world treats old soldiers and the poor.

He is pained by the 'shop till you drop' consumer mentality that infests our affluent urban middle class (this may in part explain his attraction to life overseas). Another thing he doesn't like: business activity that seeks only to shuffle existing wealth into the hands of fewer and fewer owners. Leaveraged buy outs *vs.* building a better mousetrap. He wants to help generate new wealth. Thinking about money doesn't have to be about greedy self interest. I don't know if the executive echelons of big banking are loaded with many Maxes. I somehow doubt it. Thoughtful, principled, passionate men are always in short supply.

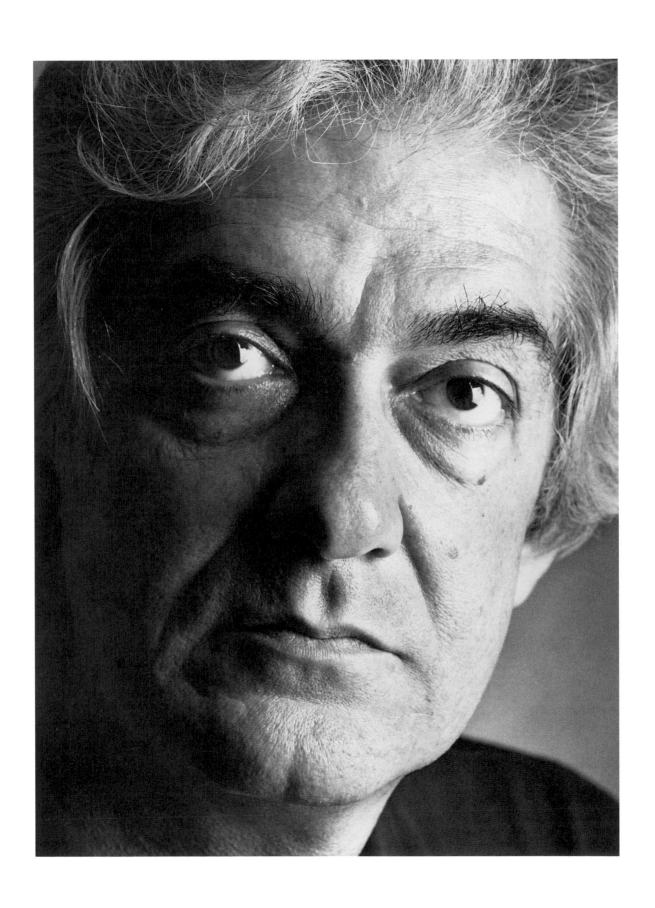

TOM HEDLEY

Screenwriter, *Photographed 1990*

Tom Hedley was by far the best magazine editor I've ever worked with. He was best because his editing was powered by a big intellectual engine, and because he was verbally and visually literate in equal measure. Hedley understood how words and images can be used to metaphorize each other. He was an art director's best friend, an illustrator's delight, and a photographer's dream. His editorial product was a careful conjoining of appropriate means, addressed to clearly defined editorial intentions.

I first worked for Hedley in 1971, shortly after he signed on as an associate editor at *Maclean's*. He'd come back to Toronto from New York, where he'd worked as an associate editor at *Esquire* for several years. Hedley and Bob Markle were old friends and Bob got us together. Before Hedley, I had met few editors with much interest in photographers, fewer still with any understanding of photographs that went past the pets, fires and broads sensibility of newspapers. I'd learned to make pretty good pictures, but until encountering Hedley I was a messy, undisciplined editorial thinker. Tom changed all that. He liked photographers, he understood photography and he insisted on a high level of photographer involvement throughout the editorial process. He assumed that photographers could think as clearly as anyone else, and if they couldn't, they learned. George Elliot and Allan Fleming had supplied a wisdom that projected me through the Sixties and Tom Hedley imparted essential insights that enabled me to survive in the Seventies.

I've spoken of Hedley the editor in the past tense not because the man is dead, but because he isn't editing anymore. In the late Seventies, he ended his career as editor at *Toronto Life*. With Robert Fulford immoveably (then) ensconced at *Saturday Night* – there were no more jobs for him in this country. Someone thought of letting him create his own magazine, but the publisher hit a fiscal bad patch and the project aborted.

Canadian magazines in the Eighties tend to trade in something the industry calls *lifestyle*. Lifestyle has a lot to do with food and toilets. Bathrooms rival royalty as 'hot' cover imagery. It's not that Tom couldn't give good bathroom, it's that he didn't want to. Instead, he took all his verbal/visual faculties and went to work writing screenplays for films. He was good at it. Hollywood was his oyster. He wrote Flashdance. He's rich. I love it when friends prosper.

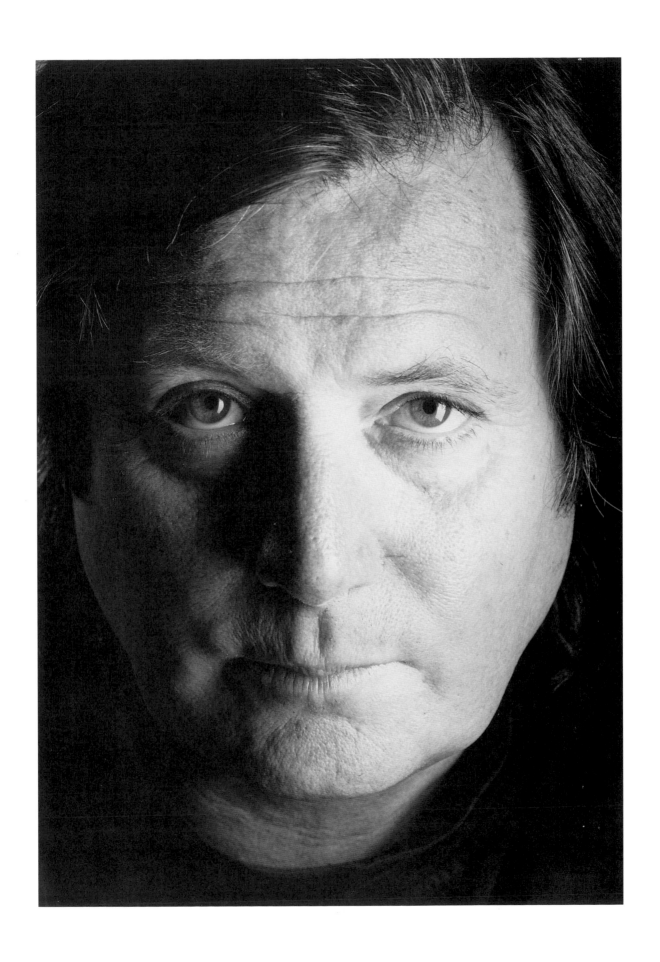

SUSANNA HOOD

Dancer, *Photographed 1989*

Susanna Hood is a whole lot younger than I am. She falls into the niece category in the Reeves' constellation of self-selected siblings.

I photographed her parents' wedding in 1962. I admired the infant Susanna in her crib shortly after her 1970 world debut in a Montréal Drummond Street apartment. Only children tend to be socially and intellectually precocious because they spend their early years hanging out with grown-ups. I don't remember Sue ever being a child. She simply shed her diapers, fixed whoever was nearby with her plate-sized eyes and became a soignée sagacious thirty-five-year-old.

By the time she was twelve, dancing had become a full fledged passion. She spent three years in the Pre-Professional Program at The School of Dance in Ottawa. Then, there were three years at the Royal Winnipeg Ballet School's professional division. She is currently in her third and final year with The Toronto Dance Theatre's professional school. Nine arduous years in dance schools have paid off. The on-stage Susanna is an evocative, sensual, charismatic presence. The avuncular heart goes pitter-pat, the chest swells with pride, the shirt buttons strain.

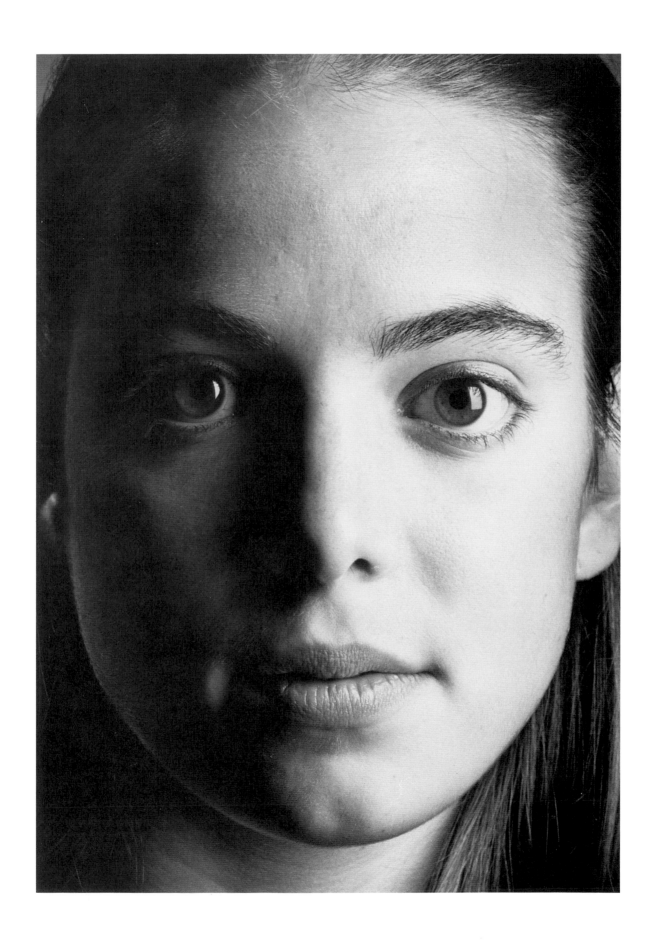

ZACHARY SOLOV

Dancer, Choreographer, *Photographed 1989*

Canada isn't always generous to her most gifted citizens. In recent years, a growing group of our finest intellects have been heading out to race tracks to make some decent money and distract themselves by musing on the glories of the horse. These are men of fine sensibilities and it's inevitable that beautiful racing venues become totally attractive to them. In the Sixties, Saratoga Springs inspired Lucius Beebe to write Summers in Saratoga for *Esquire*, one of his beautifully rendered celebrations of high style in America. I have several friends who regularly summer at Saratoga and when they do, Zachary Solov sees to it that they are housed, fed and watered in a manner consistent with their thoroughbred aesthetics.

His Toronto friends brought the hospitable Saratogan to sit for me in mid-winter, 1989.

There is a kinetic flicker about Zachary that compels the eye, even when he's sitting down. He moves continually, the hands are ever at work making evocative gestures. The facial features are never in repose. This is a guy who charges right up your lens.

Dance is communication manifested by using a vocabulary of body language, so it wasn't surprising to learn that Zachary danced fourteen years for the legendary Georges Ballanchine. His Ballanchine years were followed by a twenty year run as the first American-born choreographer for the Metropolitan Opera.

Zachary was born in Philadelphia, the child of poor Russian Jewish immigrants. Their lives would have been sufficiently difficult without the added stress of their both being 100% speech and hearing impaired. You can't help wondering about the things that drive people. Did Zach become who he is because he had to dance for his supper, because visual means were the way to communicate in his strangely silent childhood home?

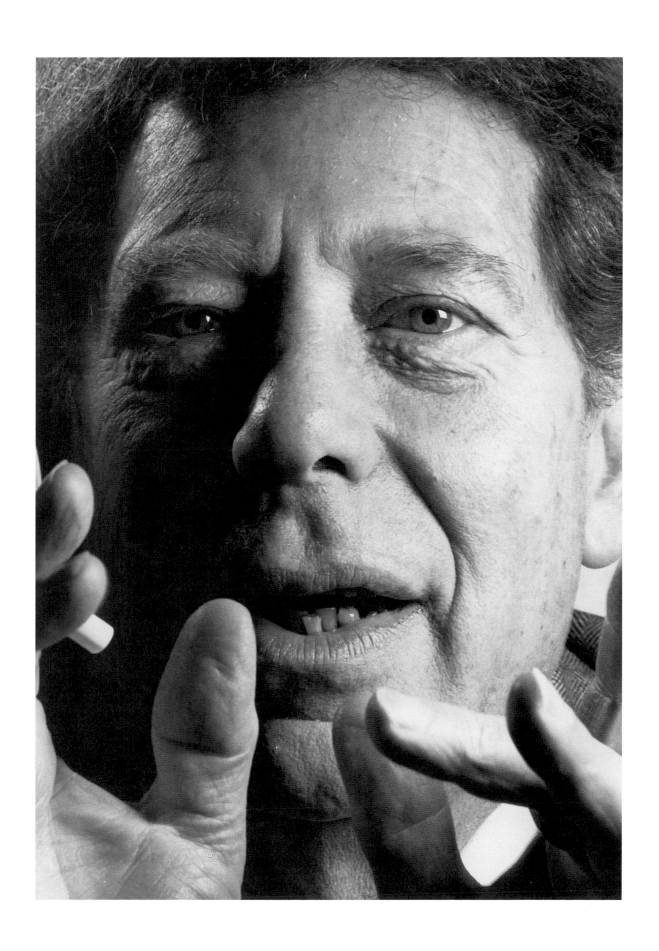

RONNIE GUGLIETTI

Taxi Dispatcher, *Photographed 1988*

Ronnie Guglietti's presence towers over radio cab dispatching in Toronto the way Picasso towered over Art in the twentieth century. His achievements invite analysis.

Consider the voice. Ronnie's dispatch syntax embodies a feel for cadence, meter, and a reverence for diction learned by listening to Frank Sinatra's LPs. "Voice dispatching is a kind of singing," he says, and a Guglietti call for cars during a rainy rush hour is a powerful, poetic chant. "Give me cars, cars in the east end Diamond – Fallingbrook and Kingston Road, Silver Birch and Queen, Carlaw and Eastern … cars …" and so on for some thirty locations to a call. Ronnie once dispatched 320 orders in sixty minutes. Calling thirty locations means that some eighty vacant cabs are going to try telling their dispatcher where they are, so hearing is the voice's flip-side. The Guglietti ear can resolve all that sonic chaos into essential information – who's booking and where they are – and then: "Gentlemen listen to your radio please – 1332 get … 980 get … 434 get …"

I drove a cab in the late Fifties. As a part-time driver, my car numbers changed a lot. Ronnie never met me, never knew my name, yet one radio transmission was enough for him to know that it was me (that specific voice) booking. "OK, you're driving 934 tonight – get Sick Kids Emergency for Mrs. Simonhi."

Voice, ear, brain. Ronnie Guglietti looks like an intellectual, and ultimately his sensibilities are driven by the powers of his mind. Most taxi dispatchers learn a city's geography by driving cabs. Ronnie, however, has never driven a car of any kind. His Toronto is a creation. The city is an exquisitely detailed place that took shape in his mind with help from maps and fleeting glimpses snatched while riding in streetcars or other people's passenger seats.

These days Ronnie is dispatch manager for Diamond Taxi. He's spent most of his thirty-seven-year career with Diamond. Sinatra doesn't sing with skiffle bands, and a great dispatcher needs a really big fleet of cars to make his adrenalin pump. Four years back, Diamond converted to computer dispatching and now Ronnie tends to a swift, silent Gandalf dispatching system. So, things have changed. Still, even computers demand time off, and that's when it happens. Ronnie goes to the microphone and one more time the king of the voice dispatchers starts sending the big Diamond fleet on journeys through the city he built in his brain.

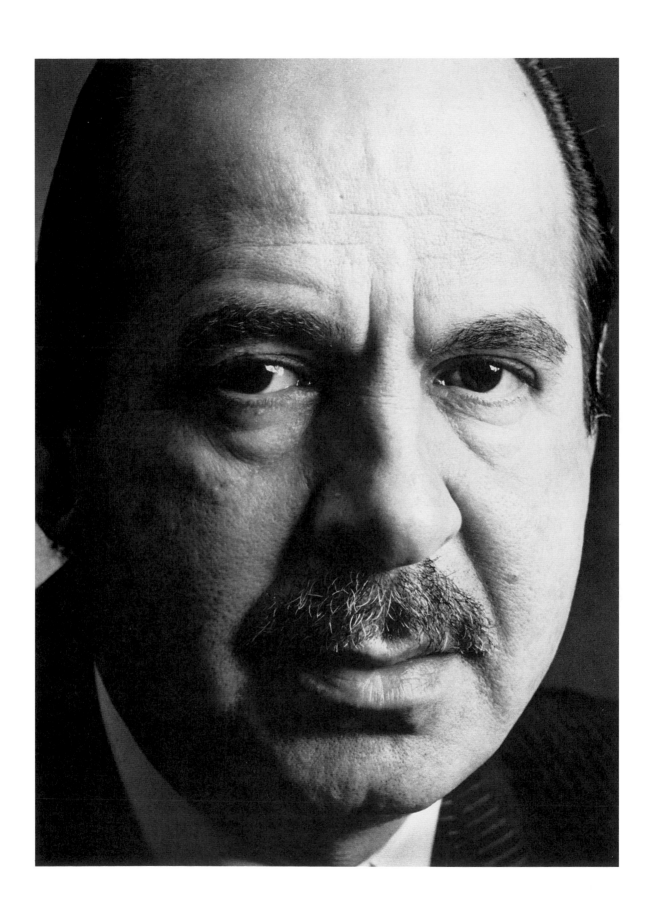

JON EBY

Art Director, *Photographed 1989*

The media environment somehow decided that the Seventies was to be, among other things, the Woman's Decade. The United Nations decided that 1975 would be International Woman's Year. Women were a major topic for all magazines, and since I am rightly categorized as "a people shooter," I gave careful thought to the way women were treated as subjects for magazine journalism. I have to say that they were not and are not treated well.

Female media worthiness has always been afflicted by the Conspicuous and Cute Syndrome. That is, conspicuousness (she reads the weather on television) and cuteness (great teeth, nice hair, wears clothes well) is confused with substance. We are presented with an endless stream of distinctly un-cute men (most cabinet ministers, jocks, and academic jive talkers), but an important female scientist or a distinguished author who doesn't come packaged with the right Conspicuous and Cute quotient – well, it's sorry baby, no cigar.

Comac Communications' *Homemakers* was the best women's magazine in Canada. It made serious efforts to present its readers substantial, intelligently treated stories. With strong support from art director, Jon Eby, and *Homemakers* editor, Jane Hughes, I developed a portrait attack that involved making graphically well constructed photographs while leaving my subjects free to be themselves for the camera. That meant they chose the location for the shoot. They were allowed to wear their own clothes, not Conspicuous Cute stuff foisted on them by some ostensible (*red* makes our readers happy) fashion guru. Further, my subjects didn't have to submit to "improvements" to their own ideas about appropriate hair styling and make-up. Out on the *Homemakers* trapline, I like to think that for a little time I managed to bring Eby some well made, honest images of intriguing women: clairvoyants, stockbrokers, centenarian music teachers, merchant mariners, and important female politicians.

Alas, magazines don't have me out on the road searching for great women these days. Eighties publishers have a whole new set of preoccupations. Out with women's stuff and in with Conspicuous Consumption stuff. Our newsstands groan under huge loads of trivial cogitations about how to live, where to live, what to wear, where to wear it, what to eat, where to eat it.

Art directors are the playmakers of visual journalism. They should aim to get their visual offensive team (photographers, illustrators) positioned so they can score. Eby's creative leadership didn't so much involve directing artists to execute solutions for his problems; rather, he lured them to think along lines that allowed them to find his solution for themselves. His respect for his artists' intelligence was an attractive quality, and it made shooting for *Homemakers,* and Comac's other Eby art-directed magazines – *Quest*, and *City Woman* – a pleasure. Tom Hedley made me smart in the Seventies. Jon Eby made me busy.

Sadly, the Eighties saw Comac lose its brains and then its bank accounts. By 1987, all Comac's key personnel, including Eby, had left the company. A new group of owners floundered, desperately seeking fiscal redemption with awkward attempts to climb aboard the consumer/ lifestyle bandwagon. They failed.

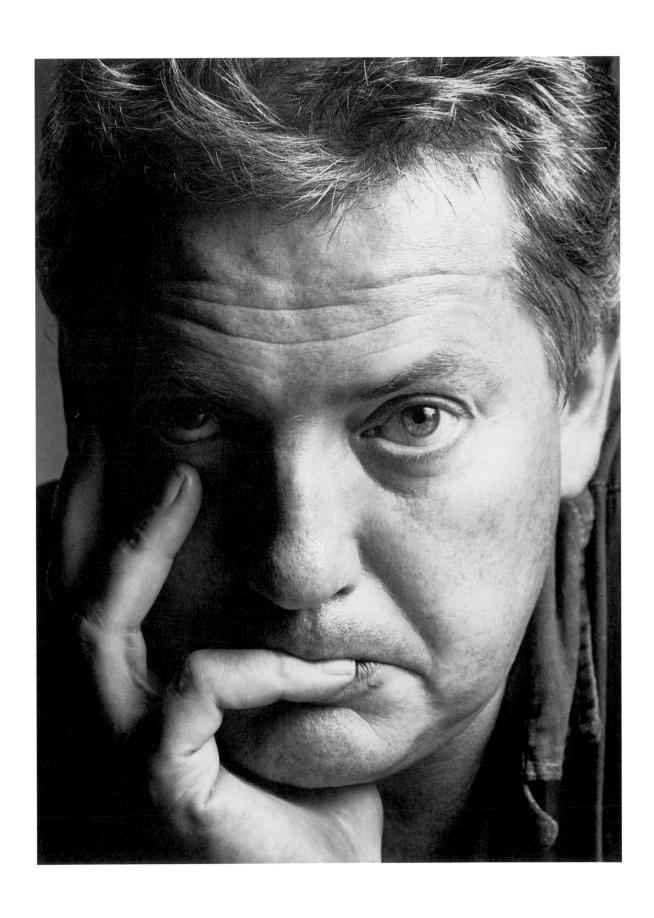

DOROTHY CAMERON

Sculptor, *Photographed 1990*

The Dorothy Cameron Gallery, at 840 Yonge Street on the eastern fringe of Toronto's Yorkville district, existed from 1959 to 1965.

Contemporary Canadian art wasn't just an enthusiasm for Dorothy, it was a passion, a rapture, an enchantment. The gallery never really operated as a business. Dorothy exhibited art that she thought people should see rather than art she thought they might buy. The designer Don Wallace created the installations for each show. A Cameron exhibition was always a unique, audaciously curated, beautifully staged, carefully produced art event.

Dorothy made extravagant efforts to get around the country and find out who was out there artistically and what they were doing. She built a strong Québec stable that included Rita Letendre, Françoise Sullivan, Roland Giguère, and the incomparable fibre artist, Micheline Beauchemin. At the same time, she represented the B.C. sculptors Richard Turner and Elsa Mayhew. There were lots of mid-westerners, such as Ron Bloore and Maxwell Bates. Hers was very much a National gallery. There was an interesting social dimension surrounding an event at the Dorothy Cameron Gallery. It was a place where the Vertical Mosaic not only encountered the *vie boheme*, it got right down and boogied with it. I recall some memorable post-opening parties at very stately homes: John David Eaton's place; Nick and Marnie Laidlaw's; Jesse and Percy Waxer's big house up in York Mills. In Dorothy's world, artists went everywhere she did.

The Cameron Gallery closed in 1965 in the aftermath of something called the Eros Scandal, which was a piece of juridical gimcrackery – about obscenity that ended stupidly. Apart from that, the Gallery's cash flow couldn't sustain Dorothy's national scale of operations and her celebrative, rather than profitable, exhibition program.

Then, Dorothy started searching for passion, rapture and enchantment on a more personal level. She fell in love with – and remains happily married to the painter – Ron Bloore. They have lived like cultural lotus eaters sojourning slowly, sensually around the world, incubating their appetites for exotic ideas, sights and sounds. In 1978 Dorothy embarked on an inward journey through Jungian psychoanalysis, which among other things, gave her a firm grasp on a system for analysing the imagery in dreams. For some years now, she has been at work on a body of sculpture which draws on her insight into dream imagery with stunning effect. The pieces are charged with the Cameron passion, rapture and enchantment. They are important, poignant, personal, compelling works of art. They belong in the National Gallery.

Dorothy Cameron is another of my self-selected relatives. This eccentric extravagant, exuberant, generous, altogether magnificent woman is a self-selected favorite Aunt. Auntie Mame Cameron.

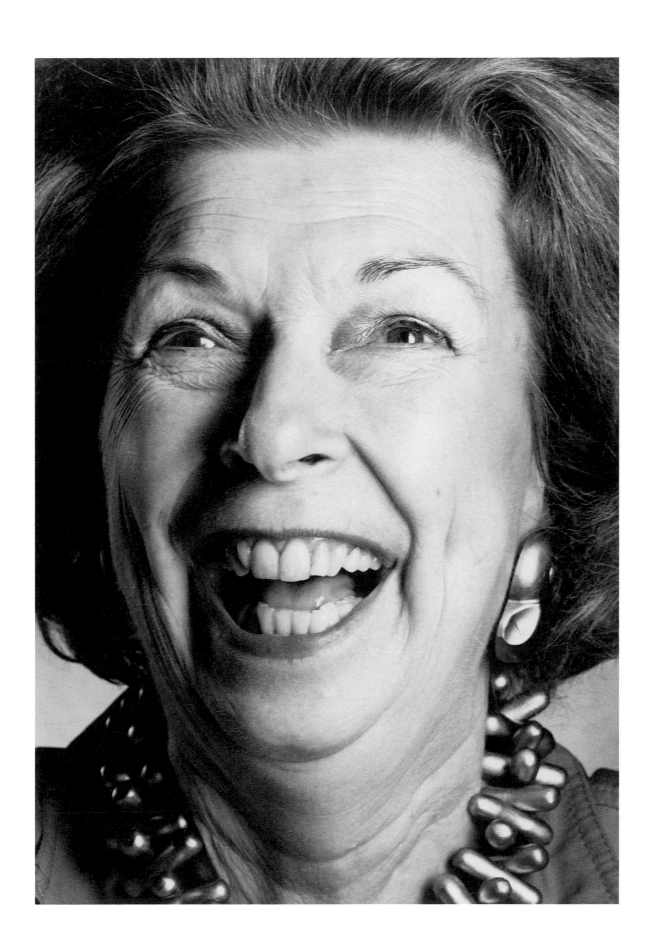

BERT BELL

Photographer, *Photographed 1990*

He's the Debussy of the Deardorff camera. Bert has a kind of tissue sensitivity for photographic and reproductive procedures that, coupled with his hot wired visual aesthetic, make him a truly awesome talent. Bert is the biggest cat in his particular jungle.

In a good year, Bert will shoot 25% of the print liquor advertising in Canada. His exquisitely crafted images have become commercial icons. A rigorous black-in-black study for Black Velvet whisky so perfectly evoked the client's sense of their product that the ad ran in the national magazines for years. The client spent fortunes trying to produce new B.V. images, but nothing quite did the job. The Black Velvet photo was the most seen image in the history of Canadian visual culture.

Objects speak to him; relationships between shapes and colors fascinate him. He is a perfectionist. He will have a craftsman trim half an inch from the rim of a brandy snifter that looms too large in its relationship to the bottle beside it. He spent years in search of the perfect artificial ice cube. He now makes his own and sells them to other photographers.

What makes this magnificently obsessed man tick? Perhaps the answer lies in this: most people endure a difficult, often frustrating work life to maintain a reasonably serene and orderly private life. With Bell, the reverse is true. His difficulties and frustrations are in his private life. He's had three unsuccessful marriages, and three expensive divorces.

At times, his business affairs have been tangled. He's had a particularly explosive relationship with the Federal Department of Revenue. His huge cash flows haven't always been reflected in substantial retained earnings. He has had a penchant for recreational extravagances that make restaurateurs and barkeeps weep with gratitude.

All this is frenetic and true, but for Bert Bell, photography is peace, order, silence, and refuge. When Bert looks through the groundglass of his 8 × 10 Deardorff he enters a resonable world that he can understand and control. He can be exact. A man tends to be very good at things he does to stay sane.

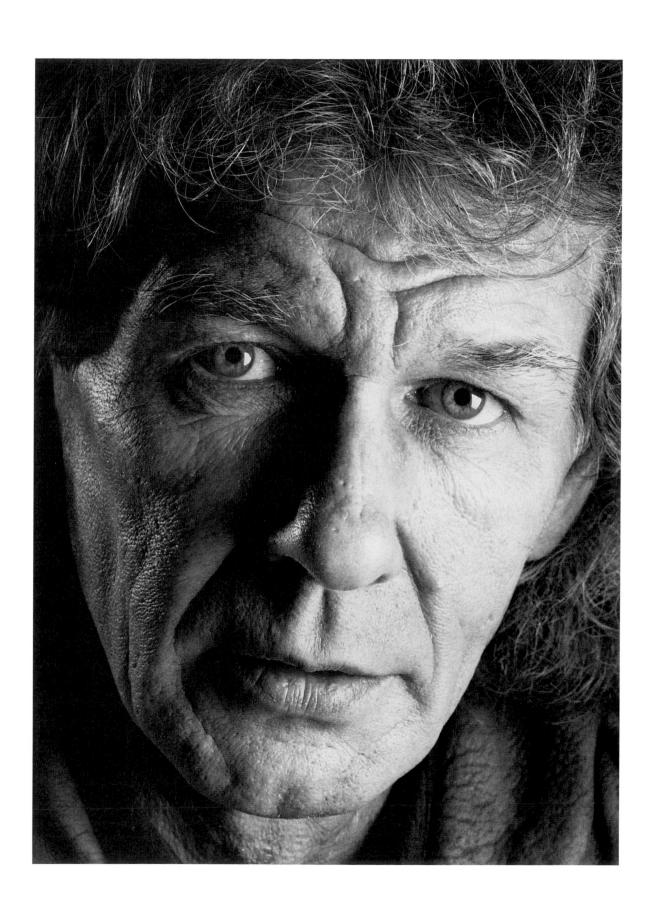

MUNDEL LOWE

Musician, *Photographed 1988*

Some time early in 1988, I got terminally fed up with photographing cute people who seem to be busy making pretentious pottery or execrable fibre art which they sell to feed, clothe and house cute kiddie clones of themselves. Cute people pictures are taken on assignment for dorky lifestyle magazines that have the word *leisure* or *living* somewhere on their masthead. I needed a change of scene and more importantly, a change of subject matter.

It was Gene Lees who suggested that I come out to California, maybe hang out at the chateau Lees 90 minutes north of Los Angeles in the Ojai valley, and maybe get serious about working on portraits of jazz musicians. The idea was perfect. Jazz musicians have always been my ultimate heroes. If I could have been Zoot Sims or Sonny Stitt I wouldn't have been Reeves the photographer. I knocked off nine shoots in fourteen days. When you're taking good pictures, you get a warm tickly feeling in the solar plexus.

I was about two rolls into my shoot on Mundel Lowe when it hit me. "Damn, this is an interesting man." He's interesting to look at, he's interesting to listen to. He's a wonderful guitarist and it's a bloody great pleasure making pictures of him. I felt great, I felt dignified. I knew the cute people had to go.

They say the truth makes you free. After my April '88 California trip, I drifted into a photographic feeding frenzy. I accumulated a large body of new portraiture. The work attracted attention. A dinner guest bought a big print of Artie Shaw off my studio wall. Better yet, Gene Lees and I contracted to produce a book of Jazz Portraits for McClelland & Stewart. There's a lesson here: when I don't like what I'm doing I should do something else.

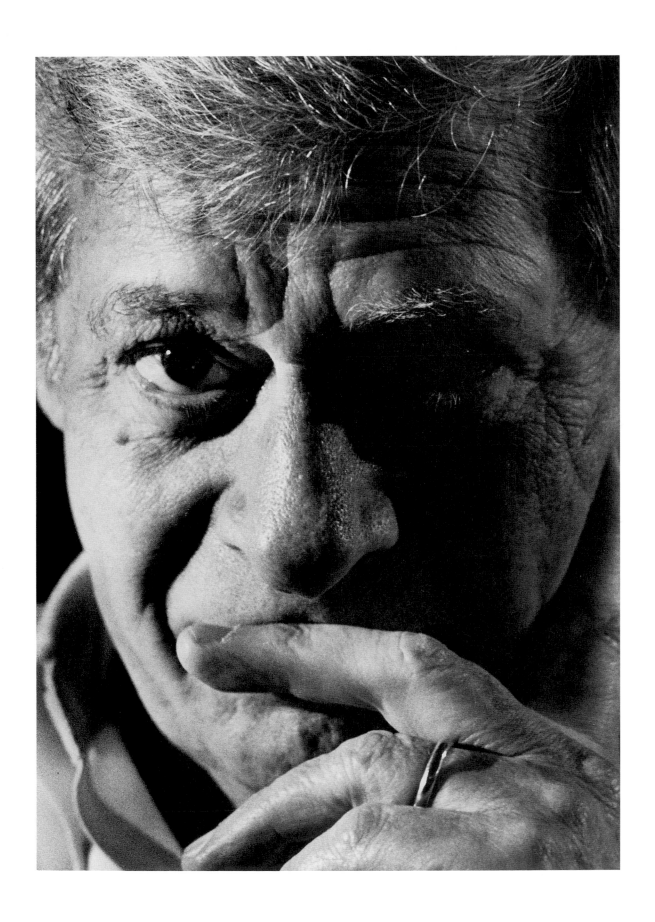

JACK McCLELLAND

Publisher, *Photographed 1981*

Jack McClelland doesn't have a face: he has a landscape that sits atop his shoulders. Looking at McClelland compels the viewer to confront the way existence's exigencies can render permeable matter into forms of terrible beauty. McClelland's face is a frighteningly honest guide to his character – excess, eccentricity, compassion, strength, and arrogance all dwell there. You understand that he will always be "looking for the card which is so high and wild." Like all aristocrats, he has always been self-employed. Like all aristocrats, he always knew how to make governments work for him. During his tenure as more or less owner and chief executive at McClelland & Stewart, the company was his vehicle for a very personal, unique, utterly admirable passion to publish books. He made stars of popular historians and poets alike. Look well at Jack McClelland. He is that rare man who has altered his corner of the world forever, and for the better.

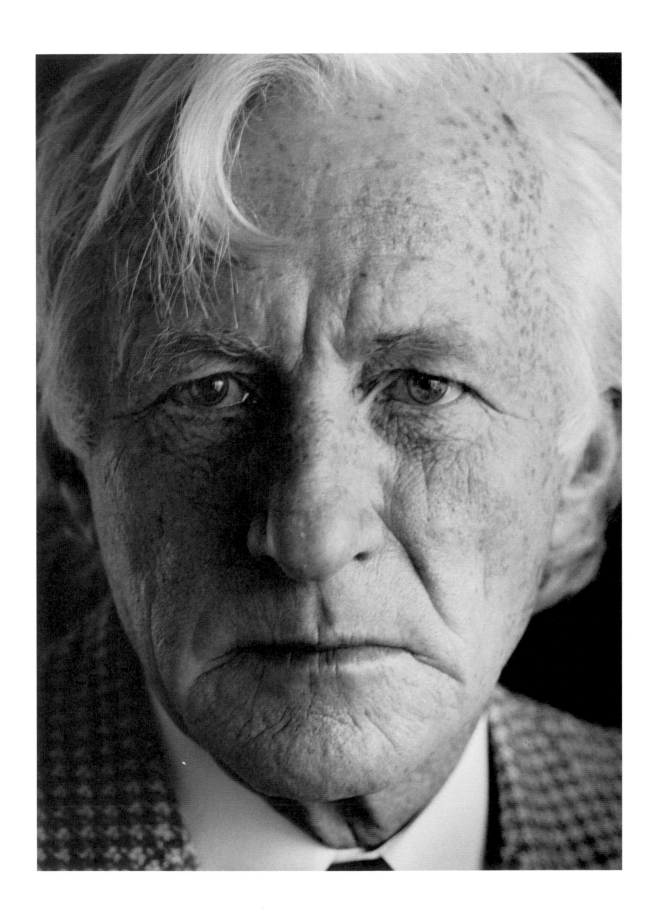

PETER STOLLERY

Canadian Senator, *Photographed 1990*

Fleeing the wrath of the "mad Niab of Raz-el-ara," this man once galloped into Aden on a camel. He saw the last parade of the Foreign Legion at Sidi-bel-Abbes – the wooden hand of Captain d'Anjou reposing on its velvet cushion in the bright Algerian sun. Elsewhere, the landlord of the Sind (who drives a 1947 DE SOTO) gave Stollery his choice of all the women in the land. But Stollery has a hot foot, he was moving too fast to pitch tent. He's been to Fernando Po, and one of his best friends is a cousin to the Sir of Swat (who or why, or which or what – is the Sir of Swat?). He was the only North American to cross the Sahara in the summer of '59, and one of the few to ever travel Central America's trackless Mosquito Coast. Not satisfied with having "walked where Helen walked," he felt impelled to cycle to Miami in the winter of 1969. He has bedded down in the Grand Hotels, and lived for weeks in a hammock. He's had adventures so exotic and bizarre that their presentation awaits a posthumous memoir!

Over the years, Stollery supported his appetite for adventure by periodic bouts of clerking in his family's staid men's wear shop in Toronto. Then, he drove cab for a while. Around 1970, Stollery was possessed by a vision of electoral politics as paying employment. He got himself nominated to run for the Federal Liberals in Toronto's big downtown Spadina riding, and lo and behold he upset the incumbent member in the 1972 election.

Stollery functioned well in Pierre Trudeau's Ottawa. The years in Algeria had made him beautifully bilingual in French. He was the exemplary bi-cultural W.A.S.P. For a couple of years, he chaired the Liberal Caucus. Spadina's diverse voters sent him back to Ottawa four times.

Prior to Trudeau's retirement, Stollery was asked to step aside to facilitate the election of a favored prime ministerial aide named Jim Coutts. The voters were asked to surrender a popular member and give their support to an unknown. Spadina was safe for Stollery. It was murderous for Coutts who has suffered crushing defeats twice at the hands of a crotchety socialist called Dan Heap.

Respect for party discipline got Stollery the Senate. He's having fun in the Upper House. There's all that ill-considered Tory legislation so in need of lengthy contemplation, and of course, there's been Meech Lake, that consitutional vessel crying out for a merciful torpedo amidships.

Stollery sits on an inter-governmental committee for North/South relations. Naturally, his Spanish is fluent. He's lunched in Buenos Aires with Jorge Borges. He's breakfasted in Bogota with the (until now) indestructible chief of Colombian State Security, General Masa Marquez, and of course, he's accumulated more material for that posthumous memoir. The Senator is a man who lives his dreams. He's the last Rider Haggard Hero.

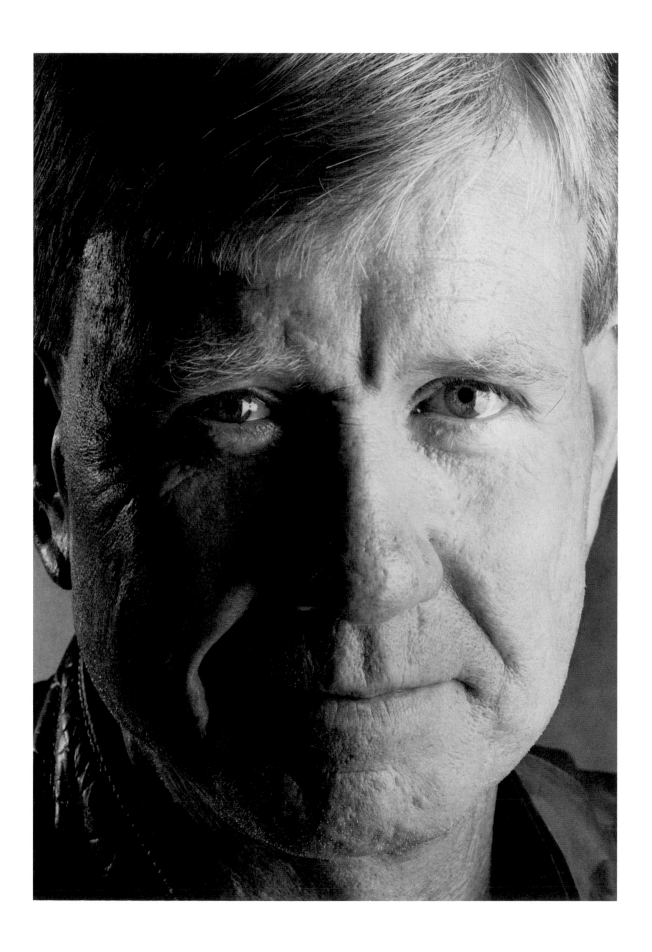

DIMITRI BISTI

Vice President, The Russian Academy of Arts, *Photographed 1990*

It seemed that I ought to make the effort to buy a bottle of Russian vodka, some smoked salmon, and some black bread. Boris Ugarove and Dimitri Bisti, the president and vice president of the Russian Academy of Arts were in Toronto to negotiate an exchange of exhibitions with the Royal Canadian Academy of Art.

I was going to make some photos for the R.C.A. archives. I'd heard all the stuff about Russians and vodka, but mightn't it all be just a bit exaggerated. Wouldn't two circumspect, artistic emissaries prefer to drink some cautious cups of coffee. To be safe, I fired up the studio coffee machine and brewed a big jug of Medaglia D'Oro.

My subjects arrived and an offering of coffee received tentative acceptance, but then – ah, vodka. Mr. Bisti spotted the Moskovskaya. He poured a shot for Ugarov, he poured a shot for himself, he poured a shot for me. We had that jar of white Russian lightning half-gone before I remembered to turn on the lights and load up my Hassleblad. Lordy, we were in a mellow mood. Jeepers didn't we have a hell of a time. Bloody right. I've got pictures to prove it.

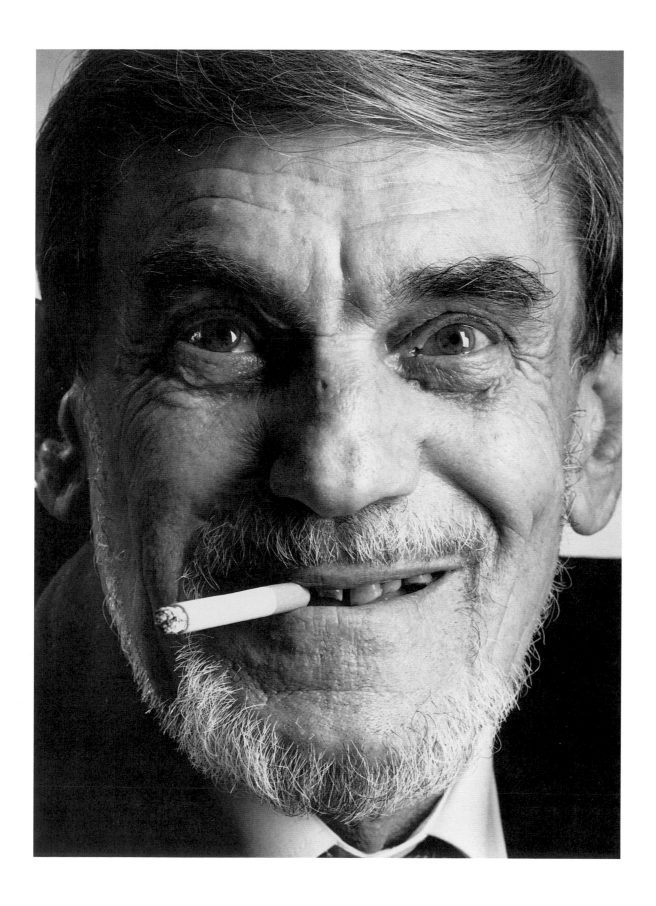

PETER CROYDON

Photographer, *Photographed 1989*

There is about Peter Croydon the demeanor of another place and time. It's easy to imagine him clad in immaculate evening attire, a discreet display of medals on his breast pocket, murmuring perfectly polished witticisims into the ear of a beautiful pale poetic lady, as they waltz with effortless grace beneath softly glowing crystal chandeliers.

Croydon was raised British and middle class near Croydon, a London suburb on the edge of the Surrey Downs. He was born in 1924. The world he grew up in still retained a little of the lustre of its Edwardian heyday. His background marks Croydon to this day.

He was introduced to photography by his grandfather, Harry Buckland. Buckland had spent years adventuring in the vast British Empire of the late 19th Century, and he had established the Tasma Photo Studio in Woolwich (another London suburb) after returning from a Tasmanian sojourn in 1892. Croydon was a lonely unhappy adolescent and a mediocre student. Photography intrigued him. He left school at sixteen and began working for his grandfather.

The next year, war broke out and in 1941 he joined the Royal Air Force and took special photographic training at No. 1 School of Photography, Farnborough, graduating with a grade of 99% – the highest mark recorded by the school, higher even than T. E. Lawrence (of Arabia), who shortly before had passed through No. 1.

In 1945, Croydon was sent on a special assignment to Italy, photographing government documents for the British Foreign Office. During his Italian year, he took a lively interest in non-photographic matters. Europe excited him and he cultivated interests in wine, food and art. He had a phenomenal ear for languages and he became fluent in French, Italian and German. A love affair in Rome with a beautiful Pole led to an astonishing command of Polish and to an obsessive fascination with every aspect of Polish history and culture.

He left the R.A.F. in 1946, and found his way to Toronto. Croydon's technical skills and refined aesthetics sent him to the forefront of Canadian commercial photography. The Canadian Association of Photographers and Illustrators gave him their 1988 award for lifetime achievement.

Croydon is not only a practitioner of photography, he is a scholar as well and it is not surprising that he is now a teacher of photography at the University of Delaware. Croydon can speak with Élan about tri-chrome carbro printing or Atget's aesthetics. He is also an oenophile and chef, and if you want to talk about Galcynski's poetry – in Polish if you like – or if you want to discuss how various cultures visualize ghosts, then Croydon's your man. Add sartorial elegance, urbane manners and a glittering wit (often mistaken for arrogance), and you have an Edwardian gent gone astray in the Nineties.

Croydon's contributions to photography have been enormous, but damn it, the man could do so many other things. Should he run a superb restaurant or buy a vineyard or deal in 14th century Italian paintings or become ambassador to Poland?

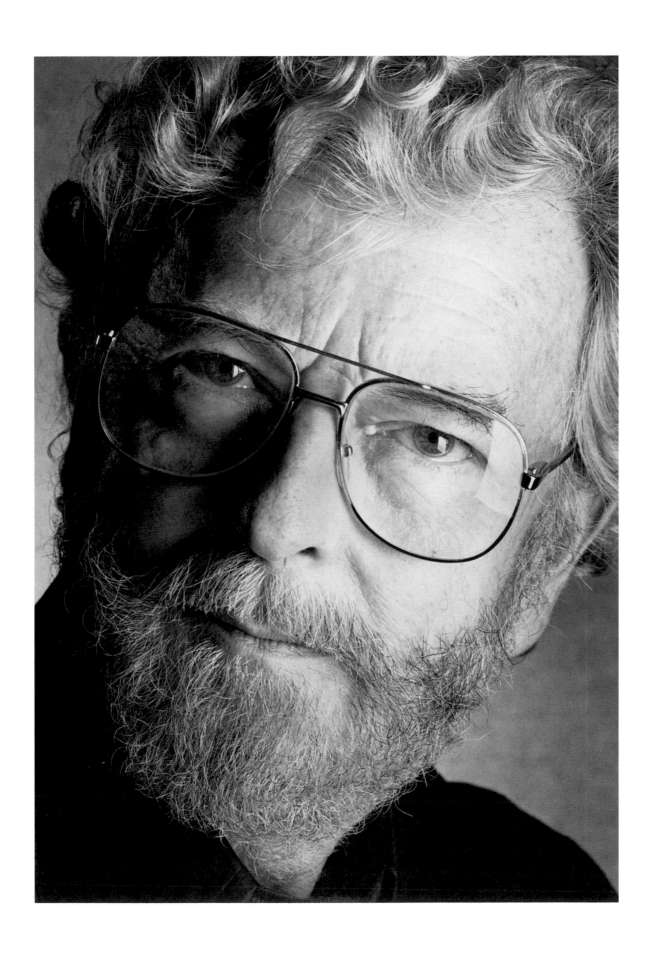

HAROLD TOWN

Artist, *Photographed 1987*

I first photographed Harold Town for *Time*'s Canadian edition in March 1964. We spent several hours together, and he talked to me a lot. He talked about old movies and John Barrymore. He talked about new movies and Marlon Brando. He talked about Fra Angelico, Picasso, and Frederick Varley. He talked about Jack Kerouac, Al Purdy, and Irving Layton. He talked about Mussolini, Churchill, and Harry Trueman. He talked about Glenn Gould, Horowitz, and Dinu Lipatti. He talked about them brilliantly. Town was the most bewilderingly eclectic scholar and the greatest master of verbal style I had ever met. Harold Town is legendary for his ability to draw. Drawing is about the mind moving the hand to create apparent forms and spaces on a flat picture plan. The ability to draw reflects the quality of the draftsman's mind and Harold Town's powerful wide ranging intellect moves his hand like no other in Canadian art. During our March 1964 encounter, Town showed me some of his Enigma drawings that were about to be published in book form. The *Enigmas* are stunning virtuoso visual performances. They move the draftsmanship of Hogarth, Rowlandson and Daumier into the post-Freudian age. Town takes us from Rowlandson's gin-drenched eighteenth century London street culture to the insides of today's gin drenched (and other substances) brains. Today the *Enigmas* number in the dozens and they constitute one of the towering performances in the history of Canadian art.

During the early Sixties, Town began moving his verbal skills into print. He produced a profusion of columns and essays for newspapers and periodicals. His critical essays are seminal to an understanding of contemporary Canadian art. His brilliantly reasoned preface to Tom Thomson: The Silence and the Storm, is essential reading for anyone with an interest in Thomson, and the Group of Seven.

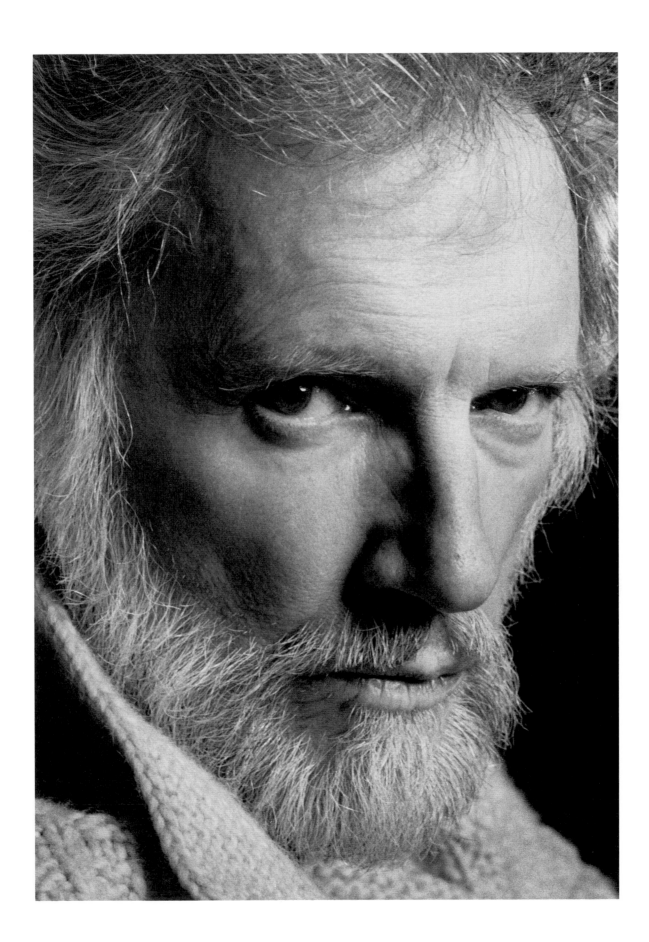

CLARE COULTER

Actress, *Photographed 1985*

Clare Coulter was a handsome, well-dressed, non-smoking, unmarried woman when she walked into my studio. But "light the lights," start the shutter clicking, and voila – she slid into the emotionally jagged, frowzy-haired, beer-and-cigarette world of playwright Michel Tremblay's east-end Montréal housewives; the kind of person she has spent so much time being on stage at Toronto's Tarragon Theatre.

Actors can be very uncomfortable in front of the camera. They often have a problem deciding who the photographer wants them be, what role he would like them to play. I'm grateful to M. Tremblay for imprinting Ms. Coulter with an accessible camera-friendly character to turn into when a photographic occasion presents itself.

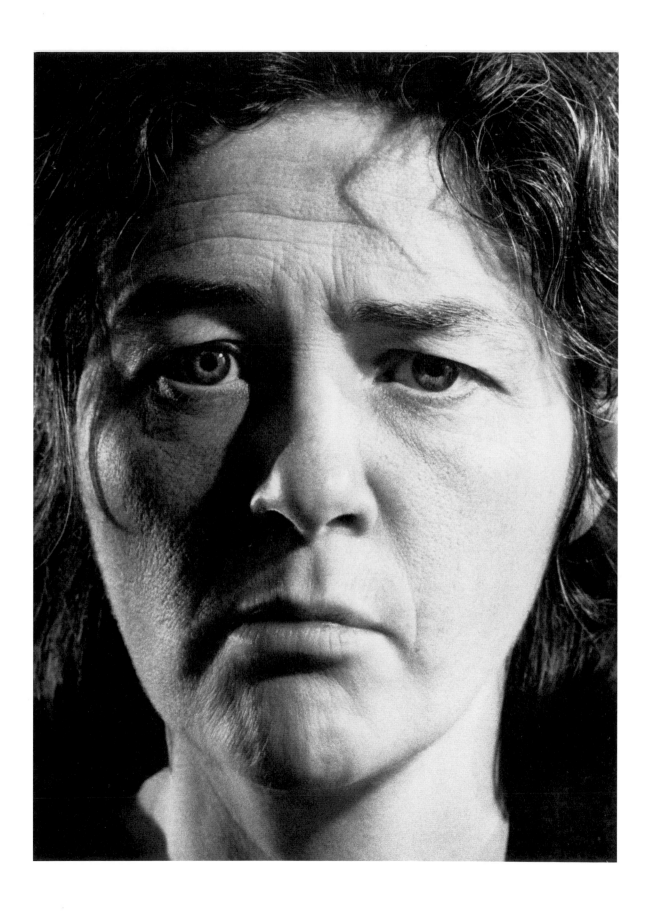

VLADIMIR GOETZELMAN

Computer Generated Film Animation Producer, *Photographed 1989*

This man probably knows more about the bewildering, complex process of film animation than anyone else around. When he left art school in 1961, he trained in traditional animation methods, all that business to do with infinities of incrementally different drawings on pieces of celluloid. Somewhere along the way, he developed a fiendish ingenuity with the technique animators call still frame animation. Still frame involves moving the camera over graphics rather than making graphics move in front of the camera. Goetzelman produced a virtuoso animated history of America and an animated history of Newfoundland using the still frame technique.

He became fascinated by the potential application of computers to the animation process, and for years he had the slickest computerized animation camera stand this side of the National Film Board.

In the late Seventies, Goetzelman began to talk about "generated" imagery; the potential for computers to go far beyond moving an animation camera around. Generated imagery means there aren't any animatable graphics. Images exist as electronic information that can be electroncially summoned as imagery on film or videotape. Obviously Goetzelman is rare, he can get his head around complex things. His discourses on the implications of computer generated imagery are electrifying. Like most people, I don't get it all but I do get the drift.

He is a very solitary man, lean and hungry from much thought, but capable of a dazzling dark wit that bursts through a perpetual twilight tristesse.

Portrait photography can resonate with the intensity and character of the communication between sitter and shooter. The night this portrait was taken, Vlad had joined the artists Christopher and Mary Pratt for dinner at my studio. He was funny as hell. He dazzled the Pratts with his rap on generated imagery. Imagine being able to turn a viewer loose to walk around inside one of Chris Pratt's cool, refined, abstracted, architectual studies. The Pratts went back to their hotel. Vlad agreed to sit. This portrait resonates with conversation between two middle-aged friends talking about the deaths of their mothers.

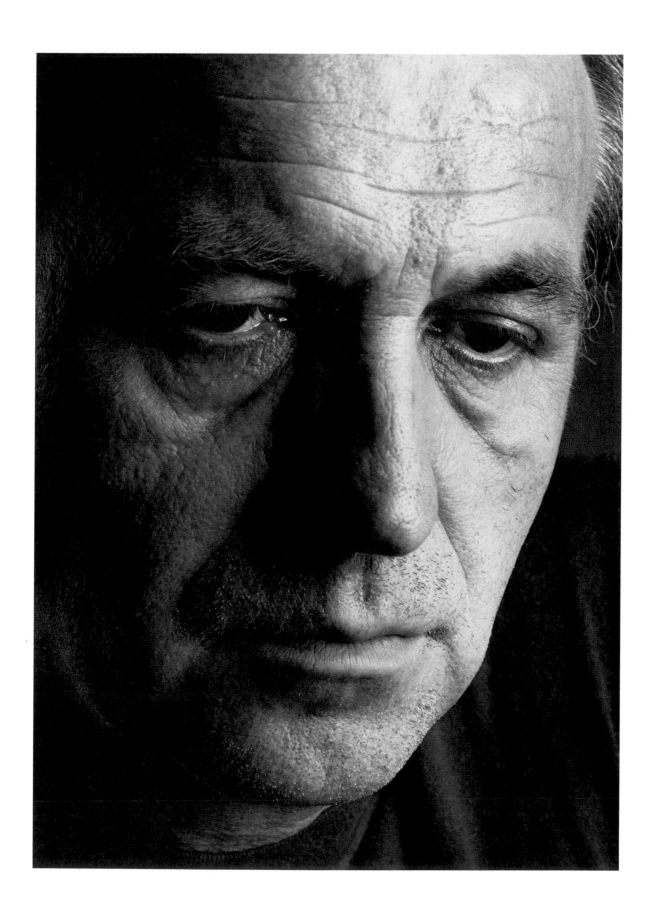

LORRAINE MONK

Author, *Photographed 1990*

It's all got to do with tossing pebbles into ponds, the flat calm placid reed-fringed Halton County farm ponds I swam in for the few years that my folks and I spent farming. Toss a tiny pebble and it radiates a few gentle concentric wavelets that quickly disappear. Bigger stones, more wavelets. Give into the urge to throw a hefty rock, and the concentric waves excited by its impact spread outward till they lap up and rebound off the pond's muddy banks.

Lorraine Monk is a big rock that got itself flung into the placid pond of Canadian photography. When she took charge of the National Film Board's Ottawa-based Still Photography Division in 1960, she immediately set about transforming what had been an in-house photo service for the N.F.B.'s film divisions, into an aggressive outward-looking agency committed to collecting, commissioning, curating, exhibiting and publishing contemporary Canadian photography.

During her eighteen years at the Stills Division, she curated 150 exhibitions and she published twenty books, including two blockbuster best-sellers: Canada: A Year of the Land and Between Friends/ Entre Amies

The Stills Division's ambitious production program generated financial support for a great number and wild variety of photographers. Pierre Gaudard's classic visceral photojournalism and Evergon's homo-erotic phantasmagoria all found a place in Ms. Monk's photographic scheme of things. She also created important opportunities for the arts and crafts adjacent to photography. Nineteen individuals portrayed photographically or referred to in the text of this book have had a significant working relationship with Ms. Monk. Allan Fleming, Neil Shakery, Ralph Tibbles, Jon Eby, Ken Rodmell, Jim Donoahue, Theo Dimson, Debbie Gibson, Ruth Hood, Gene Lees, Harold Town, Tom Hedley, Peter Croydon, Charles Oberdorf, Arnaud Maggs, Yousuf Karsh, Jack McClelland, Ernie Herzig and Georges Gurnon. Book binders, paper makers, photo-engravers, printers, poets, prosodists, exhibit designers and lots more all did important work for Ms. Monk. 1989 saw Lorraine Monk make her debut as an author of Photographs That Changed The World, a beautifully crafted popular history of photography. Jack McClelland helped project Monk into her new author role by acting as literary agent and negotiating her deal with Doubleday in New York.

I ascribe power and influence to people in proportion to their ability to enlarge and improve the environment in which they perform. They are the big rocks flung into the placid pond. They make a big impact. They make a lot of waves. By the time she resigned from the Stills Division in 1978, Lorraine Monk had become the most powerful, influential individual in Canadian photography. She's been working to establish a major privately funded photographic museum in Toronto. Let's give another toss to our biggest photographic rock.

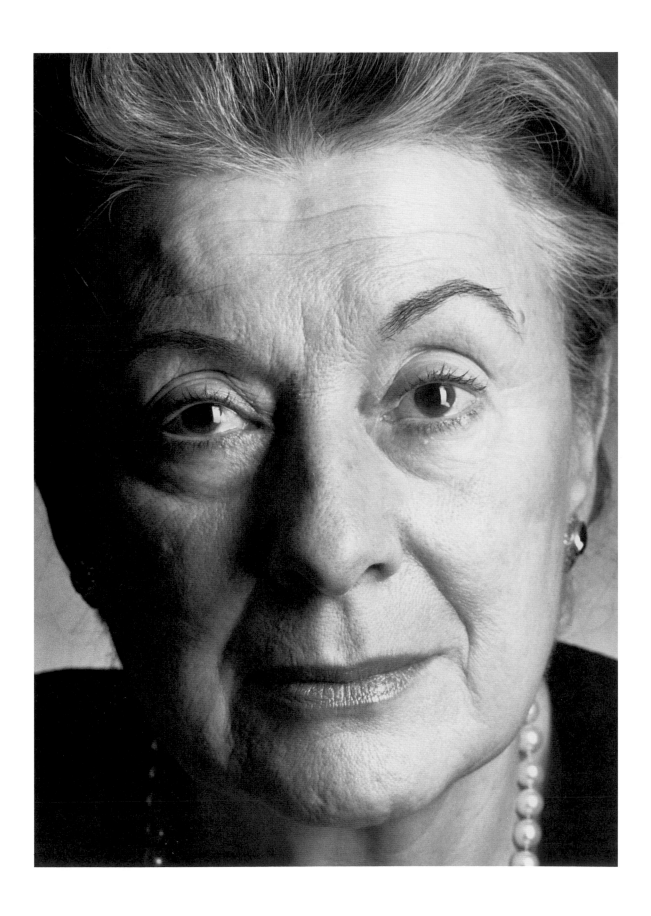

TERRY RYAN

Arts Administrator, *Photographed 1989*

The West Baffin Island community of Cape Dorset formed the first Inuit-owned Art Marketing Co-operative in 1959.

The Co-op needed a managing director and its shareholders appointed one of the Northern Affairs Area Administrator's assistants, Terry Ryan. Ryan was the first white man hired by, and answerable to, Inuit employers.

He has served his masters brilliantly. Ryan understands the upstream and downstream ends of art making and marketing. Upstream, he has been able to motivate the on-going production of quality Dorset art. Downstream, he has constructed a highly effective sales distribution system.

The West Baffin Eskimo Co-operative markets through a network of 65 art dealers in Canada, the u.s., and western Europe. Sales of one to two million dollars annually net well over $100,000 in dividends for Co-op shareholders. By the way, the pay-out of dividends is over and above the salaries for Co-op staff and the up-front cash paid to artists on delivery of completed works. Ryan's management has meant that the West Baffin Co-op has never been broke; it's never needed any Federal financial resuscitation, something that can't be said for most other Arctic Co-ops, or most other cultural operations of any kind in this country.

Terry Ryan is uniquely equipped for his role in life. The Ryan family are merchants and they still own and operate Ryan's Hardware on Queen St. East in Toronto's Beach district. Business sense is in the blood. He was also a gifted art student and a graduate of the Ontario College of Art. It's rare to find sophisticated business and aesthetic sensibilities so nicely fused in one man.

Ryan abandoned his own artistic ambitions to help the Dorset Inuit develop theirs and they respect him for what he's done. He is also Cape Dorset's Justice of the Peace and Coroner. He marries, buries and adjudicates the sins of the people that he's devoted his career to serving.

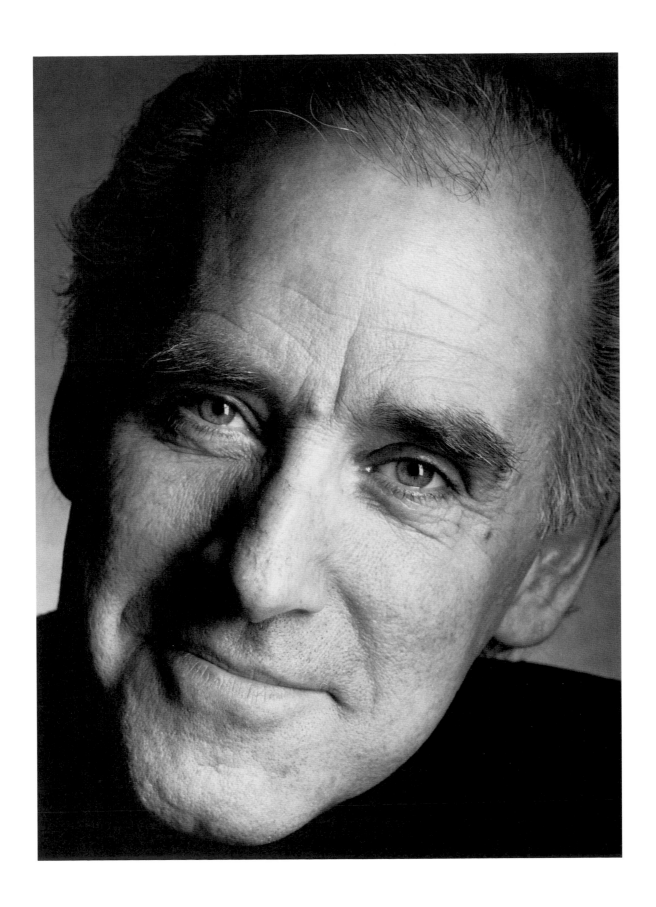

JOYCE DAVENALL TURNER

Arts Administrator, *Photographed 1989*

Joyce Turner lives with art. For her, living with art and the art of living are symbiotically entwined. The pictures on her walls, the books on her shelves, the food on her plate, the clothes on her back, the furnishings in her rooms, all resonate with an innate unselfconscious aesthetic that is part of her, just like her glorious cheekbones and great legs.

The imagery on her walls doesn't represent stature or investment. It's there to nourish a very personal visual literacy, just as her library feeds very personal literary appetites. The food on her table nourishes, but it is also a part of her intellectual and aesthetic landscape. It looks good, it excites the faculties for taste. Her clothes aren't labels and her furnishings aren't monuments to the taste and cost of the must-have interior designer of the hour. Clothes and furniture are necessities that meet their owner's juridiciously assessed functional and aesthetic requirements.

Joyce Turner is the Director of Volunteer activity for the Art Gallery of Ontario, and she is the only management level art bureaucrat that I know. I'm very comforted by the knowledge that there is a Joyce in the art bureaucracy because she is so manifestly a person who loves art. But damn it, there are hundreds of other art bureaucrats out there and I have no idea what they like – in part because they are always very emphatically drawing attention to their very specific job descriptions. They administrate, curate, adjudicate, educate, interpret, plan (long and short range), procure, market, strategize (long and short range), raise money (known in the trade as development), but how do they feel about art? I would love to think that the executive echelons of the big arts agencies and institutions are loaded up with Joyces but I doubt it. Just like great naturals of any sort, people gifted with the inclination to connect living with art and the art of living have always been in short supply.

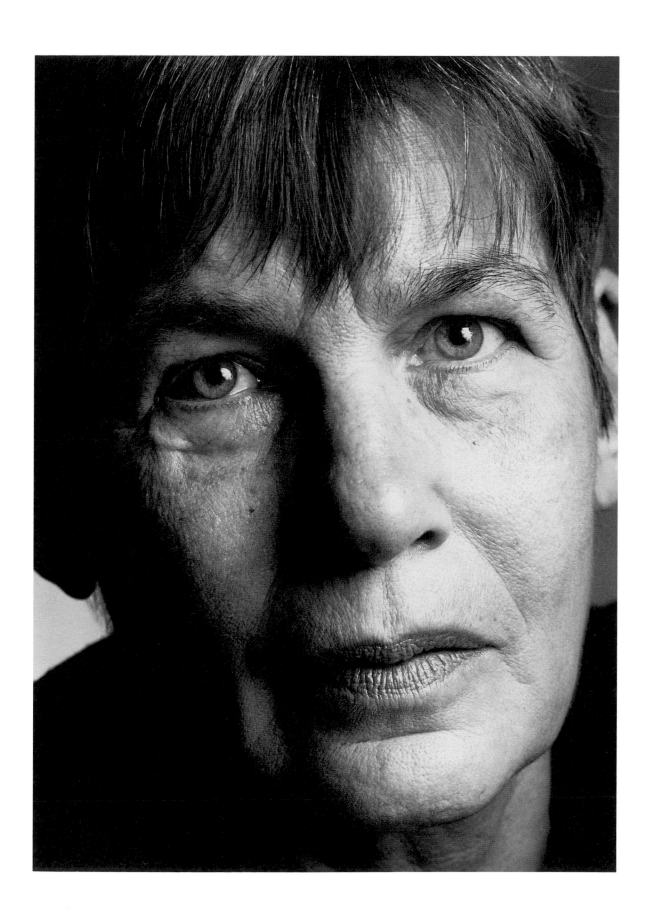

JOHN FILLION

Sculptor, *Photographed 1990*

*"My violence is born of my outrage at the inadequacy of making art that
can relieve no one's pain but my own."*

John Fillion's life has been a search for serenity. His searching was propelled by his ability to identify and embrace a series of intellectual and philosophic disciplines that all contributed to enabling him to surmount spiritual stress and proceed to the next weigh station on his particular path to enlightenment.

As an adolescent, Fillion was a devout Catholic and an altar boy. Next, he became obsessed with snooker. Snooker afforded opportunity to make perfect gestures, to know moments of clarity. Fillion's snooker skills were sufficient to rate table time at the most legendary Toronto pool hall, Smirlie Brothers Uptown Billiards. Then, he was attracted to military service. He didn't sign up for the cadets or the reserves. He volunteered for the u.s. Army's élite 82nd Airborne and fought in the Korean war. While in the service, Fillion developed a fantastic appetite for literature. He reads fast and his retention is phenomenal. Literature tilted him toward art. He resigned from the army to study sculpture at the Ontario College of Art. After graduating in 1962, Fillion set about seeking to understand life through making art with a vengeance. By 1967, he had produced a body of remarkable sculpture that included a series of five related pieces called Birdmen. The Birdmen are masterpieces. Oscar Peterson bought one, Vlad Goetzelman owns two.

In 1967, Dorothy Cameron interviewed John Fillion about his Birdmen:

"I project my own fear into these frightened lonely figures. Today, if you're aware, you cannot be brave. My Birdmen have a double sense of man hatching out of the primordial egg and man aspiring to fly – trying to escape his own limitations."

In the late Sixties, Fillion became a very serious student of the Japanese martial art, Karate. Karate teaches the abandoning of ego and acceptance of its rigorous physical and philosophic discipline.

There's quite a lot of Buddhist thought contained in Karate teaching and so it was logical that Fillion evolved from the study of Karate to the practice of Buddhism. Eventually, Fillion's spiritual and philosophic contemplations moved him away from ego centered art making. He continues to teach sculpture at the University of Guelph but apart from two astonishing Buddhas for Buddhist temples, he doesn't produce much personal work these days.

Thirteen years of Buddhist practice have had a remarkable effect on Fillion. The violence born out of outrage at the inadequacy of making art has left him. He seems to have attained the serenity he was always seeking. The acceptance of things as they are leaves him free to be a loving husband and father for his wife Grace and his brilliant beautiful daughter Michele (another self-selected Reeves niece) and a warm engaging, ebulient friend. Fillion has escaped his limitations. He is the Birdman free from fear. He is airborne.

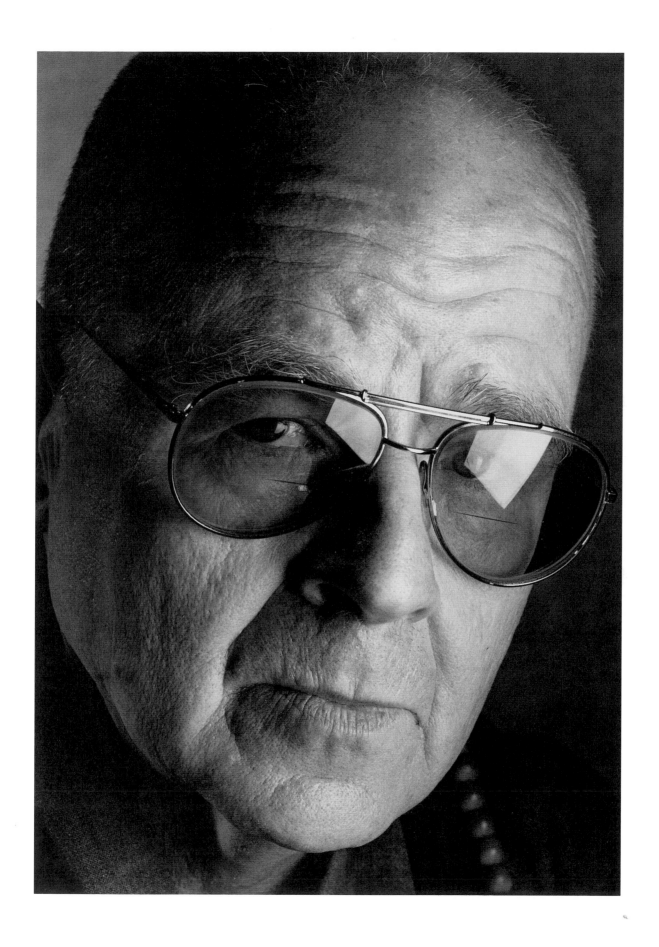

GEORGES GURNON

Restaurateur, *Photographed 1990*

349 Queen St. West, Toronto. Le Bistingo, 5:30 p.m. I am early for a drinks and dinner rendez-vous with the splendid woman known to her friends as the Tiger. The place is empty except for Michael behind the bar. Jazz is the music of my life and jazz and blues are the music of Bistingo. The discrete speakers over the bar gently enfold me with the sound of Oscar Peterson, Miles Davis and Stan Getz. My mood elevates. I ask Michael for a dry Manhattan. The Bistingo barmen make the best cocktails in the city. Art is a gesture made with great conviction and Michael's dry Manhattans have so much conviction they always taste like two. The people at Bistingo really know who their clients are, they really talk to you. This is an afternoon in October '88, and Michael knows I'm just back from Zaire. He's interested. He asks good questions. I tell him the gorillas were great, the pygmies were alarming.

Waiters start trickling in and suiting up for the onset of dinner after six. This evening's line-up includes Carlos, Richard, Marcel, Perry and Jacques. There's some easy backslapping banter. Carlos' dad lives in Zaire and I get a chance to polish my gorilla and pygmy material.

Then, suddenly, he is among us. A little smaller than most of his staff, slender, quick moving, charismatic. Co-owner and maitre d', Georges Gurnon, surrounded by his squad of waiters, reminds me of a quarterback prepping his offensive team. Georges is a great maitre d'. If he was a quarterback he'd be Joe Montana. Carlos and Co. know that Georges can uncork the long ball and they can make big yards. The Bistingo team fairly glows with *esprit de corps*.

Georges and I go back a long way, many other nights and a couple of other cafés. Years back – when our Gold cards were all fresh and undented – he taught us how to go to the trough and the till with style and dignity. He pauses to chat. My gorilla and pygmy material is by now incandescent. The first guests appear. The game begins. The backfield's in motion. Georges is rushing right over centre. The team starts executives with awesome precision. These guys are as good as it gets. "A bottle of Chateau Montelena for Msr. x (a provincial cabinet minister)." Georges smiles discretely, he's just connected with a perfect short flat pass on the first play of the game. One bottle of the big Napa Valley Cabernet always tastes like two.

She who is known to her friends as the Tiger, appears in the door. Georges is on the move, pressure on the elbow, a kiss on the cheek. Richard takes Tiger's top coat. He's a painter and they chat a little about the Markle show at the Isaacs Gallery. We're famished for some of chef Claude Bouillet's cuisine. Tonight it will be steamed mussels "en mouclads" for an hors d'ouvre. Then, for Tiger, black tagiatelle and deep sea scallops. For John, medallions of Provimi Veal. We will both want a salad after the entree and then, perhaps, if it's in good condition, a little Saint André cheese. The Tiger and John are red wine drinkers and Perry counsels us to select the '86 Duckhorn Napa Valley Merlot.

The food arrives. The Tiger smiles. Oral stimulation, optical delight, taste bouquet, textures, temperature, color and shape. It's all so damn sensual. It's another touchdown for Gurnon, chef Bouillet, and the great Bistingo team.

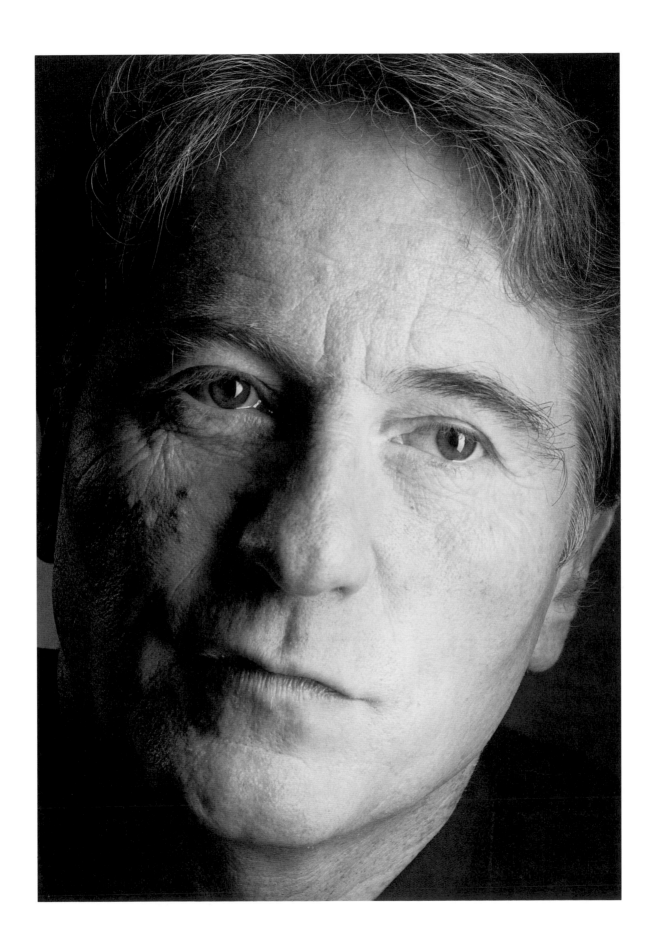

DIZZY GILLESPIE

Musician, *Photographed 1990*

I didn't want the Diz puffing up his cheeks. I didn't want the Diz popping his eyes with his wacky smile. I didn't want the Diz doing versions of the above while chomping on a foot-long stogie.

Dizzy Gillespie ain't dizzy: he is one of the great sophisticated and subtle, thoughtful and serene musicians of his age; a band leader, composer, stupefying trumpet virtuoso and mentor for a phalanx of important musicians.

Dealing with an extrovert who has a passion to perform, and a certain knowledge of what the camera likes, doesn't always make the photographer's job easy. Diz did his Diz thing. I have yardage of cheek-puffs, eye-pops, and cigar chomp negatives. Patience is golden. You wait for the moment between spasms of *schtick,* et voila – the pensive interior Dizzy, his face unfortified by extrovert armaments.

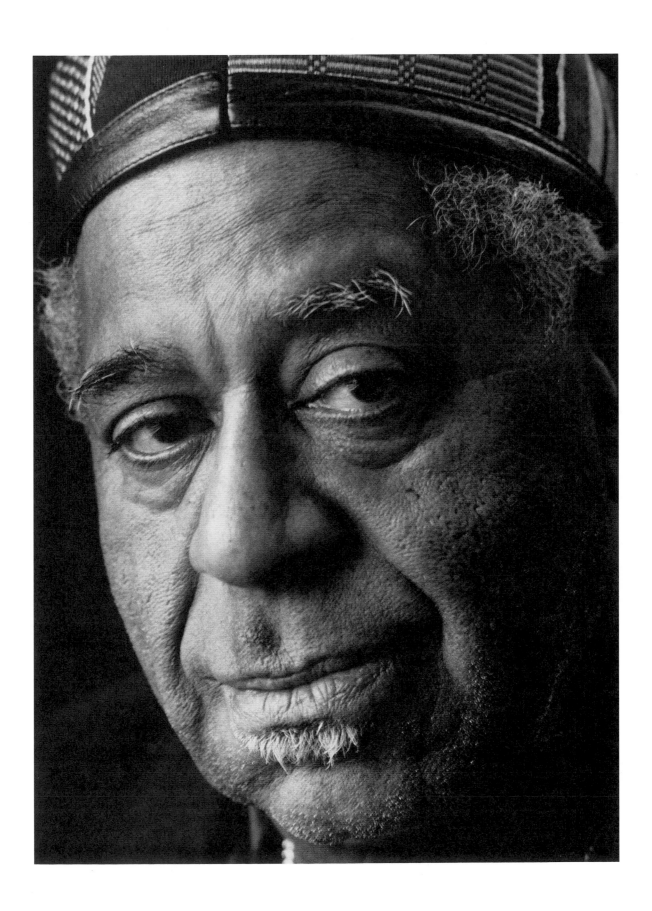

YDESSA HENDELES

Art Museum Director, *Photographed 1990*

Ydessa Hendeles is an only child, a circumstance that permits her to select for herself the family members and siblings that fate hasn't thrust upon her. Though the two have never met, I think that Dorothy Cameron would make Ydessa a very congenial altogether enchanting self-selected Aunt.

There's a twenty year spread in ages and they don't like exactly the same sort of art but these women are strongly connected by their attitudes and actions as players in the art world.

Hendeles and Cameron both find art all-absorbing, it is passion, rapture, and enchantment. Ydessa opened her Ydessa Gallery in 1980, fifteen years after the Dorothy Cameron Gallery closed. À la Cameron, Ydessa exhibited art that she thought people should see rather than art that she thought they might buy, and à la Cameron, her exhibitions were unique, audaciously curated, beautifully staged, carefully produced art events. Ydessa spoke of having a "commercial Gallery that operated like a closet museum." The same thing could have been said of the Dorothy Cameron Gallery.

Unlike Dorothy Cameron, Ydessa Hendeles had the very substantial financial resources to transform her closet museum into the real thing. In 1988, she formed the Ydessa Gallery into the Ydessa Hendeles Art Foundation. The Foundation functions as a museum purchasing and exhibiting avant garde art including photography that Hendeles perceives to be important. Hendeles wants Canadians to see what the international art world is thinking about. At the same time, she is concerned with projecting what she sees as important Canadian works out into the international environment.

An example of the inbound side of Ydessa's operation would be the Foundation's large holding in the work of the enormously influential American documentary portrait photographer Diane Arbus. On the outbound side, we see the works of the Canadian conceptual photo illustrator, Jeff Wall, making a big impact internationally.

If you visit the Hendeles Foundation's 9000 square feet of austere modernist gallery spaces at 778 King St. W. in Toronto, you'll be pleasantly surprised by the free admission and then you'll confront mostly conceptual installation, pieces of art that trade heavily in social, political and philosophical messages. Leading edge avant garde art doesn't hang over fireplaces and this ain't the Dorothy Cameron Gallery circa 1963.

Hendeles and Cameron aren't identical but there are a lot of congenial personality traits. These are both eccentric, extravagant, exuberant, generous, altogether magnificent women who share a capacity to commit fully to the art and ideas they believe in.

As an only child, I long ago self-selected Dorothy Cameron for favorite aunt. So now, if I self-select Ydessa for a cousin, I could take my aunt Dorothy and my cousin Ydessa for an eccentric, extravagant, exuberant, generous altogether magnificent lunch at Bistingo.

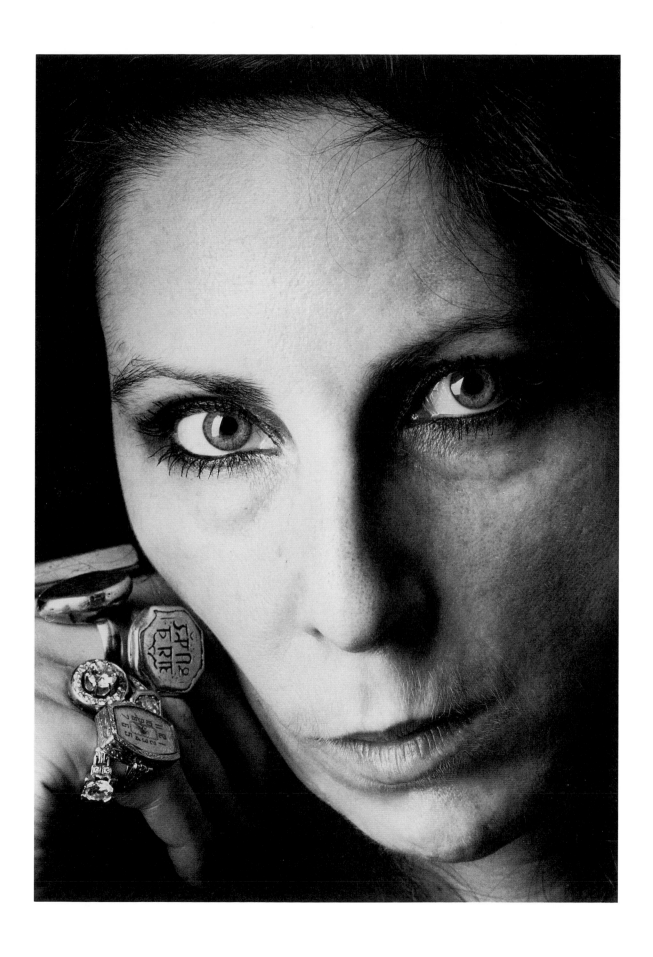

ARTIE SHAW

Musician, *Photographed 1988*

When Artie Shaw disbanded his orchestra in 1949 he was one of the most famous musicians that had ever lived. To this day he is revered by reed players as a great clarinet vituoso. His huge income, over 40 thousand 1949 dollars a week, and his marriages to mythic women – Ava Gardener, Lana Turner and Evelyn Keys – were fuel for the Shaw legend.

But then poof – he just walked away.

It's worth recalling how another more recent musical legend, Elvis Presley, was killed by his notoriety – in contrast to Shaw, who killed his notoriety.

One morbid conjecture leads to another. Artie Shaw bears a noticeable resemblance to my father. The asymetrical set to the lips, the form his cheeks assume as they engage the ends of his mouth, the trim moustache, his hair color. Artie at 79 is almost as old as my father was when he died and I can't help wondering if in time I'll start seeing all old men as shades of my dear old dead Dad.

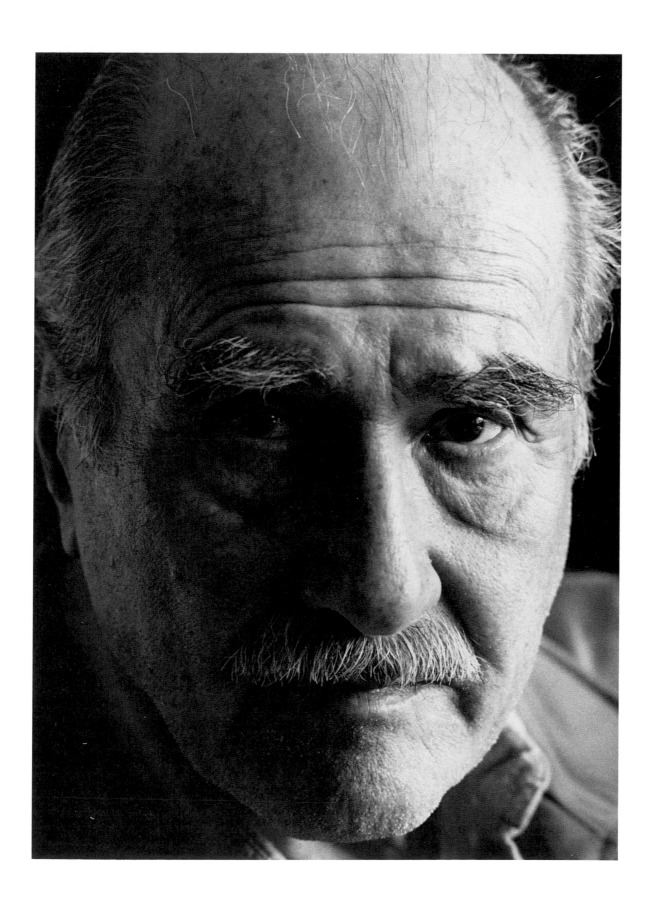

KEN RODMELL

Art Director, *Photographed 1990*

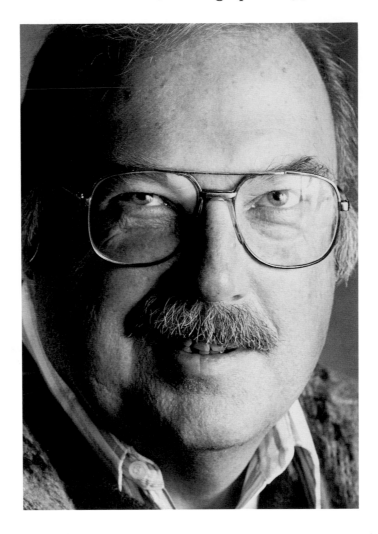

You send a photographer out to do a portrait and he comes back with a picture of himself.

KEN RODMELL